IMAGES
of America

JEWS OF PATERSON

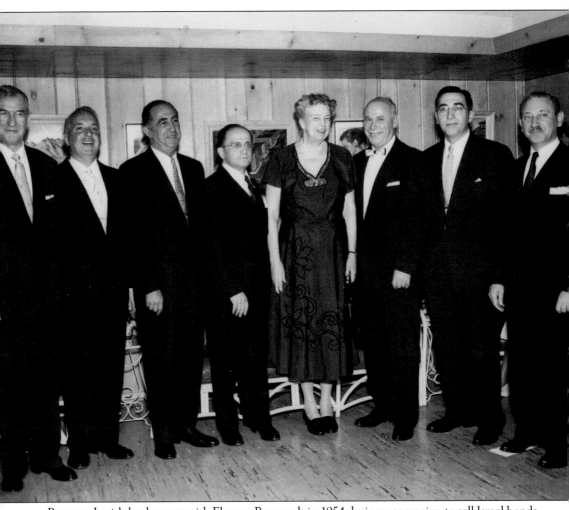

Paterson Jewish leaders met with Eleanor Roosevelt in 1954 during a campaign to sell Israel bonds. (Courtesy of the Jewish Historical Society.)

ON THE COVER: Jews came to Paterson to work in the silk mills. Small shops like this one involved the boss working alongside his employees. The workers were often "greenhorn" relatives and friends from back home. Future American success stories grew up in loosely extended families like this. The formula was for the family to pool its money to finance the children's education. (Courtesy of the Jewish Historical Society.)

IMAGES
of America

JEWS OF PATERSON

David Wilson

ARCADIA
PUBLISHING

Published by Arcadia Publishing
Charleston, South Carolina

Printed in the United States of America

Library of Congress Control Number: 2012935930

For all general information, please contact Arcadia Publishing:
Telephone 843-853-2070
Fax 843-853-0044
E-mail sales@arcadiapublishing.com
For customer service and orders:
Toll-Free 1-888-313-2665

Visit us on the Internet at www.arcadiapublishing.com

This book is dedicated to all the people with roots in Paterson. Proud and partisan, we sat down by a river, wept, and remembered, but still, life there was pretty damn good.

CONTENTS

ACKNOWLEDGMENTS

Jerry Nathans spent 30 years saving and collecting the materials for the Jewish Historical Society of North Jersey. Without Jerry, a book like *Jews of Paterson*, with such a complete and comprehensive view of life lived there, would not exist. Then, there is his encyclopedic knowledge of local history and people. Such dedication and historical knowledge deserves special notice.

The volunteers at the Jewish Historical Society were instrumental in helping me to complete this book. Not only did they select photographs, identify people, and place things into historical context, but they also demonstrated one of the book's major themes—Paterson Jews are connected to each other in many overlapping ways. Dorothy Douma Greene gave me moral support and challenged me, and her older sister was my babysitter when I was a child. Mireille Lipstiz Shuck edited the introduction. In addition to being an English teacher, she is my friend's big sister, the daughter of my grade school principal, and the granddaughter of my mother's friend Gussie, who was in the Hebrew Ladies Benevolent Society. Miriam Kraemer Gray, who helped select photographs and brought the Eastside neighborhood back to life for us, is married to a retired teacher at Eastside High School. Lou Mechanic, in an earlier life, was a yeshiva *bocher*. He explained the formal elements of *zachar* to me even though I already understood the concept intuitively. Anne Friedman Meyers knows many people who lived in Paterson and unraveled many mysteries about people and places. Ina Cohen Harris got me to visualize life in the Carroll Street/Graham Avenue neighborhood when it was going full tilt. She was also a public-school teacher who gave insight into that experience.

Jack DeStefano and Bruce Balistrieri, from the Paterson Museum, helped enormously by brainstorming, identifying resources, and providing technical assistance in using computer photograph-editing programs. The museum is such an alive and exciting place because of them. Thanks goes also to Erin Rocha of Arcadia Publishing for setting a direction and negotiating extensions. All images are from the collection of the Jewish Historical Society unless otherwise indicated.

Finally, I thank my family, at whose kitchen table in our Paterson apartment I learned the art of social commentary. My mother didn't gossip, she spoke the *emis*, the truth; my brother was my witness; and my father, a secular Jew, taught *mitzvot*, moral deeds, by example.

INTRODUCTION

The superficial inducement, the exotic, the picturesque has an effect only on the foreigner. To portray a city, a native must have other, deeper motives—motives of one who travels into the past instead of into the distance. A native's book about his city will always be related to memoirs; the writer has not spent his childhood there in vain.

—Walter Benjamin

In collecting these photographs, we are presenting a true reflection of life in Paterson through the use of images. Instead of treating them as part of an ordinary history, in which life is divided into an irretrievable past, a hard-to-grasp present, and some vague future, it is as if they have been kept in suspension to become present only when viewed. We follow the method of the culture critic Walter Benjamin uncovering archeology of the present.

This book is not pure nostalgia, a yearning for an idealized past. The photographs do evoke the *good old days* with all the warm personalities who gave us cookies, pinched our cheeks, and told interesting tales. But there is something else at work. *Zachar*, the Hebrew concept for "remembrance," is always just below the surface in how Jews portray their world. *Zachar* is historical chronology and the imperative to remember. We remember the Sabbath, we remember the Rivers of Babylon and Zion, we remember the names of our immediate ancestors, and we also remember how life in those Paterson neighborhoods created communal relationships that built and gave meaning to our lives. Even though that world is no longer physically present, when we look at the photographs of those people, streets, and buildings, we remember that world at the same time that we memorialize it. Just like placing a stone on a grave or repeating the Passover story, this, too, is *zachar*, part of the cultural DNA.

From the last quarter of the 19th century until the mid-20th century, Paterson, New Jersey, was the "Silk City of the World." The Jewish population grew with the industrial development of silk and textiles but later moved on to the surrounding suburbs following the industry's long decline.

The first Jewish settlers of Paterson were merchants and tailors who came from Germany. Some worked in the professions, but most walked the city streets as peddlers, eventually opening up retail businesses. Successful businessmen like Nathan Barnert became philanthropists and catalysts for community development. They built communal institutions to manage the settlement of subsequent generations in Paterson.

Congregation B'nai Jeshurun was formed in Paterson in 1847. By 1893, the congregation built a new synagogue, due to the generosity of Barnert, who served two terms as alderman and was twice elected mayor of Paterson. Barnert was a Jewish Horatio Alger who amassed a fortune and then gave it back by literally building many of the Jewish communal institutions. But it is equally important to remember that his philanthropic projects first originated with his wife, Miriam, who whispered in his ear to build an orphanage and a school to go along with the synagogue and hospital. They set the template for future community building and they remained role models for both Jews and gentiles throughout Paterson.

Polish and Russian Jews came in a flood to the United States after 1905, fleeing widespread pogroms in the Pale of Settlement. This could have been just another Jewish American immigrant story—the early settlers helping the newcomers set themselves up. But most of these "greenhorns" who settled in Paterson came from the large Russian Polish textile centers of Lodz and Bialystok. Many were seasoned weavers who knew how to run looms, job skills that were prized in the Paterson mills. They were not unskilled tailors who did piecework or sewed shirtwaists and *schmattahs* in sweatshops. Along with their skills, they brought strong communal ties and strong notions of how the world should work. Such notions were shared and became amplified because of the people's common background. These idiosyncratic ideas first became animated during the 1913 silk strike led by the International Workers of the World and in the character of social life in the Jewish neighborhoods of the city later on. Jews with Paterson roots may not be able to articulate this explicitly, but these values came together to make Paterson a special place for them.

Technological improvements in textile manufacturing and the continuing labor unrest led to the exodus of large silk manufacturers. By the 1930s, 90 percent of the silk manufacturing was done in small shops operated by Polish Jews. Competition was intense, few shops prospered, and by the end of World War II, the silk industry in Paterson began its decline and demise.

Yet, in its heyday, Paterson had eight major synagogues, cemeteries, religious schools, a major hospital, a YM-YWHA, mutual aid societies, charities, a kosher butcher and bakery cooperative, three choirs, an orchestra, and even a Yiddish theater troupe. Local Jewish institutions were affiliated with national Jewish institutions. Three world-famous doctors came from Paterson, as did prominent politicians, business leaders, scholars, entertainers, and one iconic Beat poet. The institutions served the community well and came in handy again after World War II by helping Jewish refugees from Europe to resettle and rebuild their lives.

The children of the old immigrants assimilated, opened businesses, and entered professions and politics. They raised their families and eventually moved out of Paterson by the 1980s, when the industrial base eroded. There are Jews still living in Paterson in a few pockets. Spiritually and emotionally, many of the Jews with roots in Paterson never left, even though they live elsewhere now. Everyone knew everyone because, at one time, they lived on top of one another in the apartment houses and the neighborhood duplexes, went to the same public schools, attended the same synagogues, did business together, played on the same ball teams, and went to the same summer camps. It was the same for their parents and their immigrant grandparents before them.

That is the historical-chronological part of remembrance. But what are the iconic images that emerge from their suspension into the present when we invoke them with these photographs? What compels us to remember? What did Paterson contribute to the Jewish collective memory?

There was not just one person in the alley off of Hamilton Avenue on a Saturday night to buy a dozen bagels hot out of the vat; people were lined up. Life was lived in public. Candy stores were neighborhood centers. The YM-YWHA was the social center for every age. Synagogues and public schools created strong bonds to add to those provided by other institutions. Children of the immigrants became schoolteachers who taught the generations of children of their neighbors, friends, and relatives. Social welfare was organized locally but enhanced by its links to national Jewish organizations. The doctors were considered to be wise men—healers rather than medical specialists. All in all, the Jews of Paterson had a strong sense of solidarity that was reinforced by all of these overlapping bonds and relationships, which still exist.

Then there are the photographs themselves. What did the photographers say to the people who posed for them to evoke such reactions from the viewers? How did they get people to relax in a way that said, "This is what I looked like and this is how I want you to remember me," just for brief moments before reverting back to formal poses?

Zachar is remembering and honoring the past as a bridge between the present and the future.

One

NATHAN BARNETT

Before he settled in Paterson, Nathan Barnert led a colorful and adventurous life. He emigrated from a backwater province in Germany near the Polish boarder to New York City. He made a fortune as a peddler selling candles and soap in mining camps during California's Gold Rush, only to lose it at the gambling parlors in San Francisco. He sailed to Hawaii because he heard that the weather was nice and that there may be some interesting economic opportunities there.

When he returned East, Barnert was the driving force behind building much of Paterson's downtown business district and he was behind the creation of all of the communal institutions. His name is associated with every major Jewish communal institution for good reason. He devoted his public and private lives to philanthropy and charity. The City of Paterson dedicated a statue to him in 1925, placing it in front of the city hall. There are not many people who are so honored during their lifetimes.

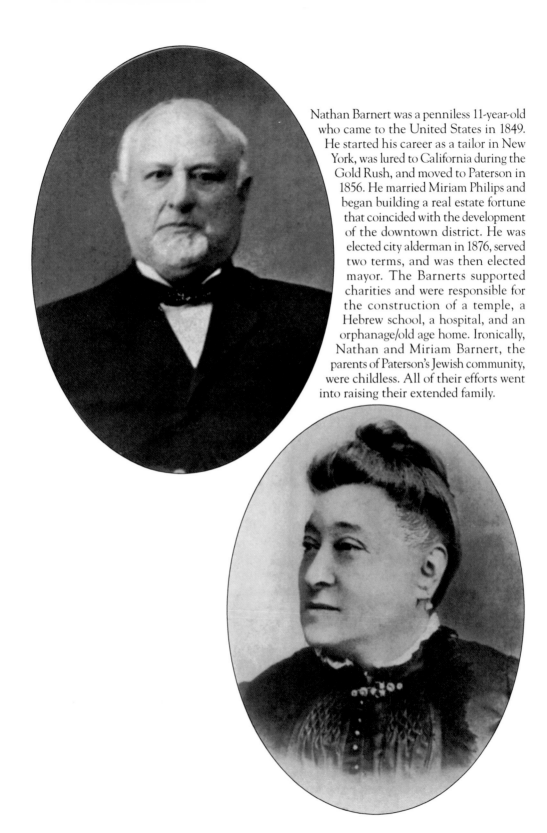

Nathan Barnert was a penniless 11-year-old who came to the United States in 1849. He started his career as a tailor in New York, was lured to California during the Gold Rush, and moved to Paterson in 1856. He married Miriam Philips and began building a real estate fortune that coincided with the development of the downtown district. He was elected city alderman in 1876, served two terms, and was then elected mayor. The Barnerts supported charities and were responsible for the construction of a temple, a Hebrew school, a hospital, and an orphanage/old age home. Ironically, Nathan and Miriam Barnert, the parents of Paterson's Jewish community, were childless. All of their efforts went into raising their extended family.

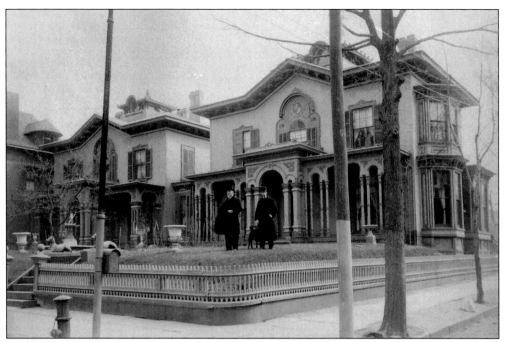

Nathan Barnert lived in this impressive house on Summer Street. The neighborhood was near "millionaires' row" on Broadway, around the corner from the Danforth Memorial Public Library. The large Victorian homes housed the city's business elite. Barnert's carriage house was later turned into the first Paterson Museum.

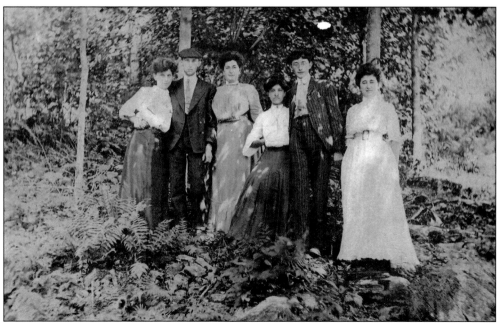

Thea Julia Barnert (far right) was Nathan and Miriam's niece. Since the Barnerts were childless, their family life revolved around nieces and nephews. Thea had just graduated from Paterson High School in 1890. She is pictured here with friends, celebrating their graduation with a picnic near Garrett Mountain.

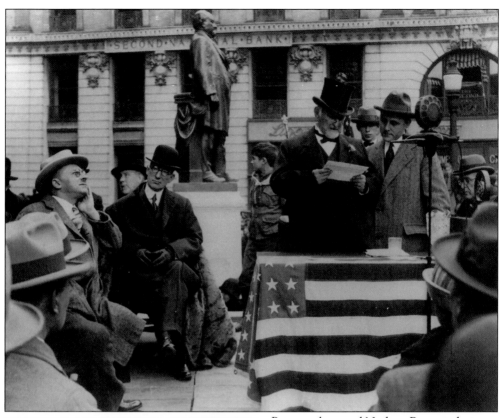

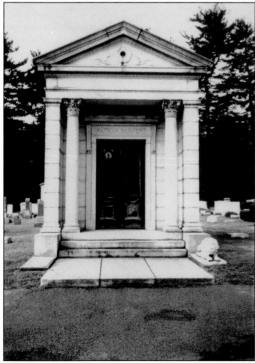

Paterson honored Nathan Barnert during his lifetime with a statue placed on City Hall Plaza in 1925. Barnert is seen here practicing his speech before the ceremony. Shown in the photograph are, from left to right, Rabbi Ludwig Roeder (hand on cheek), Judge Joseph Delaney (seen in profile), Rev. Dr. David Stuart Hamilton, Barnert, Frank X. Graves Sr. (behind Barnert and Haines), and Harry Haines. (Courtesy of the Passaic County Historical Society.)

This photograph shows Nathan Barnert's mausoleum in Mount Nebo Cemetery, the communal cemetery for Congregation B'nai Jeshurun. When a congregation forms, it usually purchases a large tract of land outside of the city for use as a cemetery. Mount Nebo is located just outside of Paterson in Totowa, New Jersey.

Two

RELIGION

In Paterson, people formed congregations based on common religious practices, shared occupations, or same old-world origins. Paterson synagogues ranged in size and formality, from members meeting in someone's house or in a modest storefront to gatherings in a utilitarian building, an elaborate Moorish-styled landmark, or a temple designed by a movie theater mogul to resemble his lavish movie palaces. The level of observance varied, and there were Orthodox, Conservative, and Reformed congregations. The synagogues became the focus for individual communities interacting and participating with others through the Jewish communal institutions that the earlier generations had worked so hard to establish. Not only did these congregants remember the Sabbath, but they also insured that their children learned how to read and speak Hebrew so that they could pray and live as Jews. The congregations also helped support the newly formed state of Israel by collecting money and clothing and providing moral support for this massive undertaking. They sold Israel bonds and brought over Israelis to teach in the Hebrew schools. And secular Jews organized several Yiddish-language schools to teach their children *yiddishkeit*, Yiddish culture. They did this with as much fervor, as did their more observant friends and relatives.

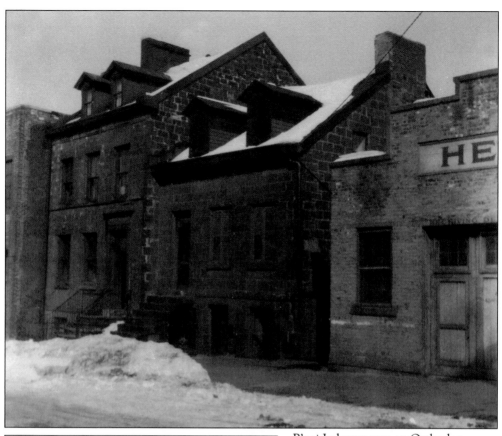

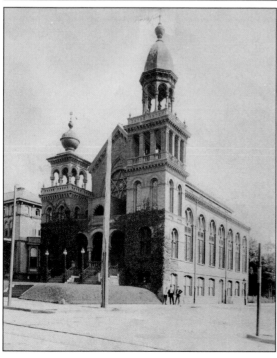

B'nai Jeshurun was an Orthodox congregation formed in 1847 by German Jewish merchants and professionals. The small congregation rented space in 1858 on West Street and moved in 1860 to 9 Mulberry Street, shown in the above photograph. Eventually, the congregation changed its affiliation and adopted the rites of more liberal Reform Judaism. In 1894, with the financial support of Nathan Barnert, B'nai Jeshurun built a two-towered, Moorish-style temple at the corner of Broadway and Straight Street. The impressive structure, seen in the photograph at left, became a city landmark. The congregation grew and moved to a new building near Eastside Park at Wall and Thirteenth Avenues in 1964. When the congregants started moving out of Paterson to the surrounding suburbs, the Barnert Temple followed them to Franklin Lakes in the 1980s.

The interior of Barnert Temple shows the bima, which is the holy ark and prayer platform. The view was designed to produce a dramatic effect for the congregation during services. Through a gradual process, the congregation's observance became more liberal than the Orthodox synagogues, and the congregation changed affiliation to Reformed Judaism. Pres. William McKinley visited Barnert Temple in 1900 for Passover. The congregation was comprised of wealthy professionals, businessmen, and silk manufacturers. At that time, members wore Prince Albert coats, high silk hats, and fashionable Paris gowns at Sabbath services and during the High Holy Days.

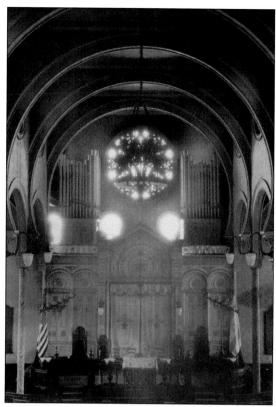

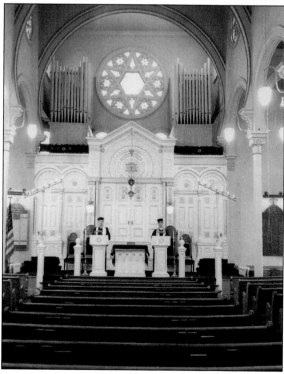

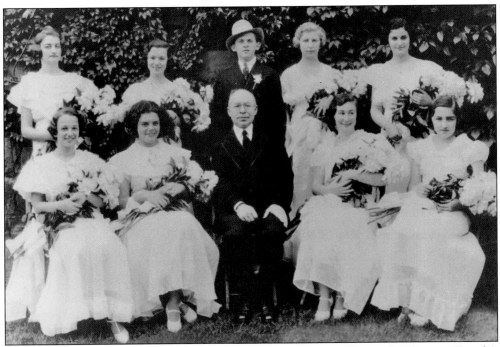

Shown above seated at center and below on the left, Rabbi Max Raisin led Barnert Temple's confirmation classes in 1934 and 1936. The spiritual leader during that period, he had a reputation for writing religious tracts and commentaries. Barnert Memorial Temple's Sunday and Hebrew schools were central institutions for the congregation. The various rabbis who led the congregation were known as scholars and people in tune with politics and public affairs. During the 1913 silk strike, Rabbi Leo Mannheimer sided with the workers against the wealthy silk manufactures, who made up a sizable part of the congregation. He was forced to resign. During the civil rights struggle of the 1960s, however, Barnert Temple's rabbi was a high-profile national figure who had the support of his congregation.

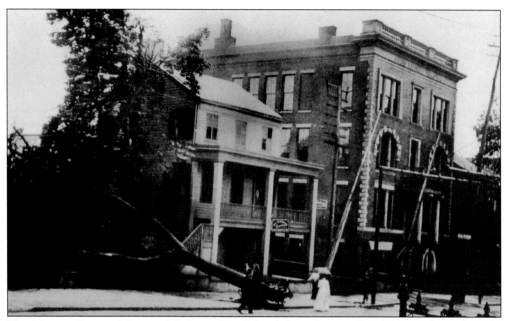

The Miriam Barnert Memorial Hebrew Free School, first chartered in 1895, was located at 176 Broadway. Nathan Barnert, to honor his wife's memory, donated the land and financed the school/congregation to fulfill the mission of providing a Jewish education for needy students. The photograph was taken just before the house and trees were removed by the city to build a railroad trestle next to the Hebrew Free School.

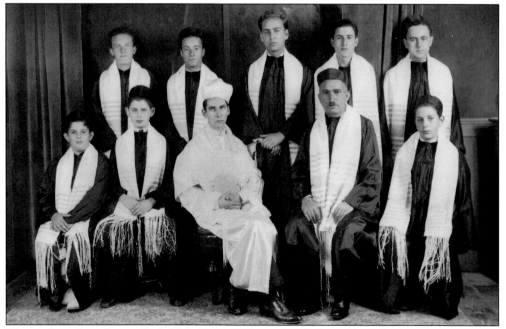

The student choir during High Holy Days 1936 posed with the rabbi and acting Cantor Morris Friedman, seated at center. Harry Bornstein, the future rabbi, is standing at center. Bornstein started as a lawyer and later became a rabbi. He was the spiritual leader of the school and congregation for many years.

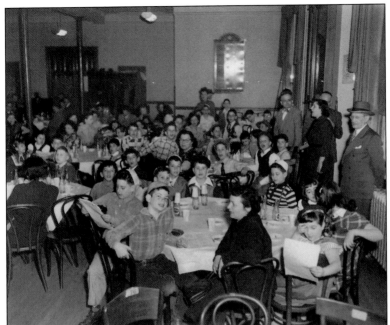

The Hebrew Free School in the 1950s held dinners that brought congregants together for all Jewish holidays. These were joyous occasions that united the entire congregation. Since the school was adjacent to the railroad tracks, these events, as well as daily lessons, were often interrupted by the passing trains.

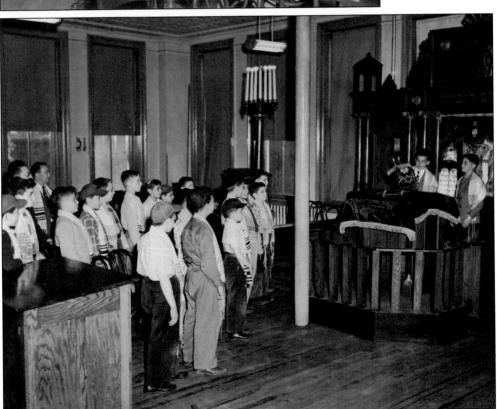

Hebrew Free School's youth service was part of the school's method of teaching by practice. Seen here in 1950, the students took on all the roles for reading Torah and leading a prayer service. The role of rabbi and cantor rotated among the students.

Burning the mortgage at the Hebrew Free School was a significant event. Retiring a major debt was celebrated with a ritual. Shown here are, from left to right, Sarah Portiz, Abe Brenman, Abe Goodman, Bunny Osur, and Rabbi Harry Bornstein. By the time of this photograph, the school had moved from Broadway to the Eastside.

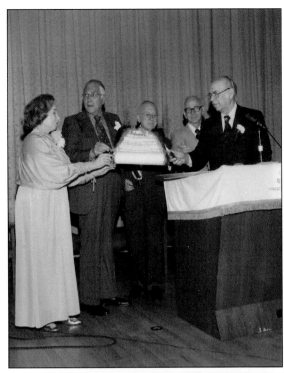

The Sisterhood was the central organizing body within a synagogue. Women did the event planning, staffed the charities, and made sure things ran on time. The Sisterhood president was a very powerful person. In this 1983 photograph, the past Sisterhood presidents of the Hebrew Free School pose for a portrait.

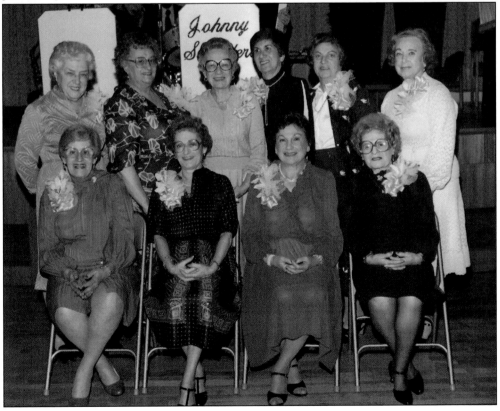

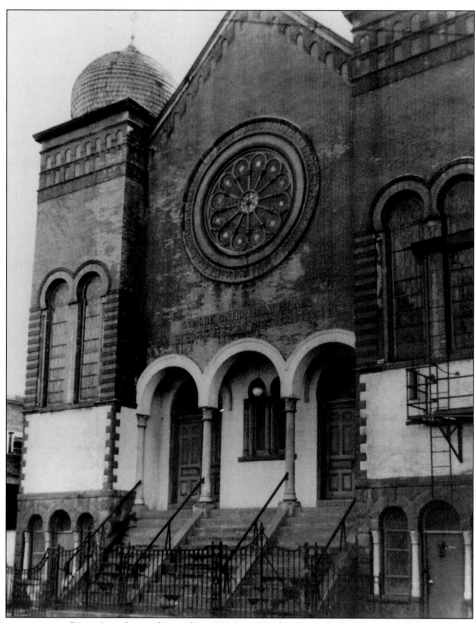

Congregation B'nai Israel was formed in 1886 at Moshe Kassel's home at 94 River Street. It moved in succession to Van Houten Street, 47 Bridge Street, and 28 Paterson Street. In 1897, the congregation purchased land at 12–14 Godwin Street, building a synagogue known as *di grosse* shul, the big shul. When the Orthodox population began to decline in Paterson, the congregation merged with the neighboring Congregation Ahavath Joseph in 1954. Beginning in the 1960s, the neighborhood began to change and decline. Race riots in 1964 destroyed much of the physical infrastructure of the neighborhood, but even more profound was the fraying of the social infrastructure. Jews no longer felt welcome in the old neighborhood, and most of the members started moving to the Eastside. Later in the 1960s, the merged congregations moved to 561 Park Avenue. The Orthodox synagogue is currently a yeshiva that draws students from all over New Jersey. They take room and board in two large mansions that border Eastside Park.

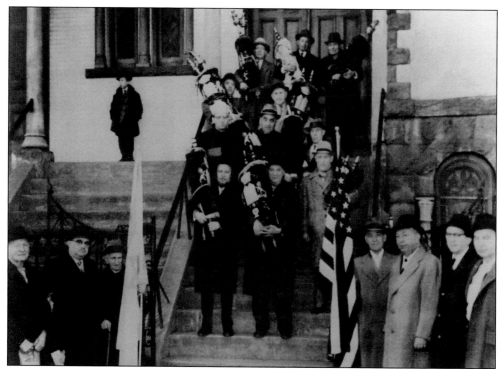

In the late 1960s, B'nai Israel moved to 561 Park Avenue. Judaism is a portable religion, so moving from a building is not supposed to be a significant event. Yet, moving does have a psychological effect upon its members. The changing neighborhood and race riots hastened B'nai Israel's move. Ritual helps with such problems. These photographs show Rabbi Meyer Greenberg leading members of the congregation on a procession, transferring 12 Torah scrolls to the new location on Park Avenue. They walked from Godwin Street, up Broadway, down Thirty-third Street, and over to Park Avenue.

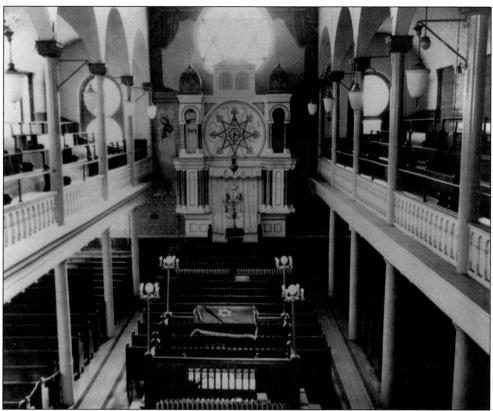

Rumanian Jews formed Ahavath Joseph Congregation in 1889. They built what Paterson Jews called *di kleine* shul, the little shul, across the street from Congregation B'nai Israel on Godwin Street. The building was more than just a utilitarian structure. The impressive dome, the scrolled columns, and the large round window were all distinctive architectural features. The above photograph shows the interior of the beautiful building, with the central bima, which is the holy ark and prayer platform, and the women's section on the second level. Orthodox synagogues house men and women in separate sections. Congregation Ahavath Joseph merged with Congregation B'nai Israel in 1954; after the neighborhood declined in the 1960s, they moved to 561 Park Avenue.

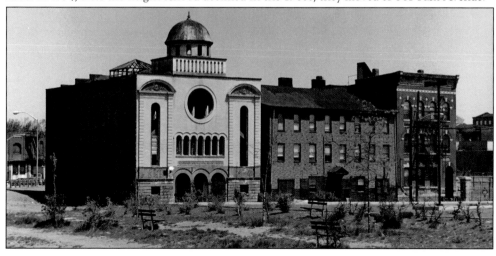

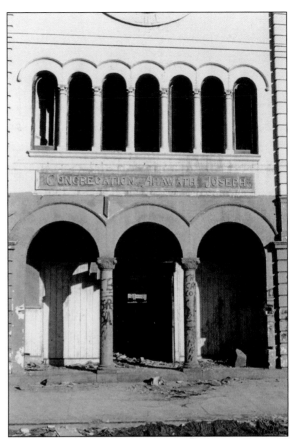

It is heartbreaking to view these photographs because they document the process of blight and neglect that have affected cities like Paterson. Via the process of urban renewal, the Ahavath Joseph building went into decline and was boarded up and vacant by the 1960s. The population changed, the neighborhood was neglected, banks stopped lending money for housing, and the city tore down the old buildings to replace them with new ones. When people cannot afford to maintain their property, they stop making repairs. Synagogues and functional retail stores hang on longer than do the residences. Ahavath Joseph hung on as long as it could, but the graffiti-covered walls seen here underscore the derelict condition of the building that was once the pride of a community of Jews.

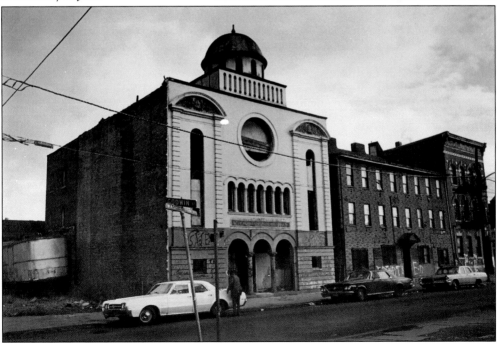

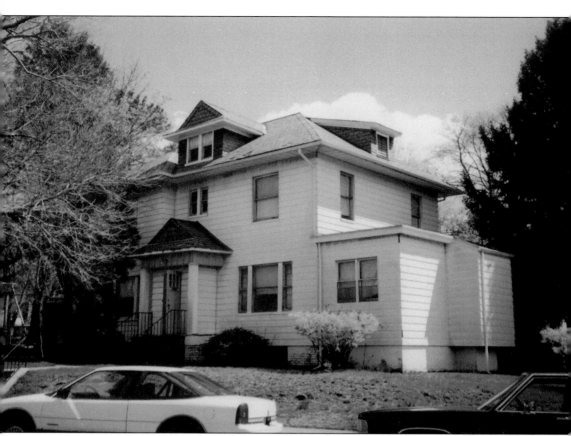

Congregation Beth Hamedresh Hagadol, known as the Water Street shul, was located on Water Street between Arch and Clinton Streets in the "over the river" neighborhood near the silk mills and the Passaic River. Its members were silk mill workers who came from the Russian part of Poland following the 1905 pogroms in their home area, known as the Pale of Settlement. The Orthodox synagogue was nestled between silk mills and School No. 4. Today, the street is called Presidential Boulevard. As the members' fortunes changed, they no longer needed to live by the mills, so they started to move out of the neighborhood. The congregation moved to 115 Vreeland Avenue, pictured above, paralleling its members' move to the Eastside in the 1960s. When the congregation finally left Paterson, the Vreeland Avenue building became a Baptist church.

The United Brotherhood Anshai Lodz, pictured above, was formed on Fair Street in 1909. It was known as the Polische shul or Anshei Lubavitch. After the riots and vandalism in the 1960s, the congregation moved to Broadway and Twenty-sixth Street. It merged with the Carroll Street synagogue Linat Hatzedek. The combined congregation eventually moved to 685 Broadway, referred to as *di stiebel*, the study house. Two doors from the Fair Street shul was the childhood home of Sen. Frank Lautenberg.

Di stiebel was located in a large house at 685 Broadway, across the street from Barnert Hospital. The combined congregation, known as Beth Sholom, was a very committed one. All the Paterson synagogues welcomed Jewish refugees from Europe after World War II, but *di stiebel* drew the most new congregants.

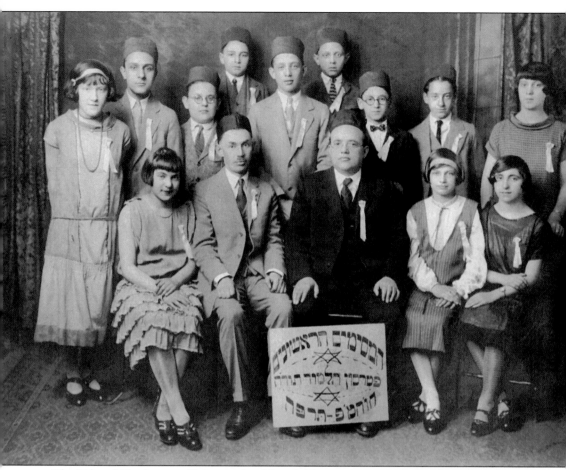

The Talmud Torah was a Hebrew school for children to learn to read and speak Hebrew, the sequence of the prayer service, the significance of religious holidays and celebrations, and how to interpret and comment on sacred texts. Children attended in the afternoon, after their day in the public schools. Shown here is the first confirmation class from Paterson in 1925 at 42 Clinton Street. It is interesting to note the distinctive yarmulkes, or skullcaps, that the men and boys are wearing. Shown here are, from left to right, the following: (first row) Clara Schneider, ? Panitz (teacher), Simon H. Schleifer (principal), Sarah Blumenthal, and Ruth Rosenblum; (second row) Helen Hamburger, David Chesney, Aaron Taylor, Philip Haft, Joe Berman, Leo Perlis, ? Ezorshy, Jack Weber, and Nettie Perlis.

The Talmud Torah building was at 42 Clinton Street near Water Street. The location was in the center of a large Jewish concentration near the public schools, rental housing, the synagogue, and a Jewish retail commercial district. While it was a separate institution, it drew students from the surrounding synagogues. The Talmud Torah eventually merged with the Yavneh Academy in 1954, moving with it to Twelfth Avenue. The Talmud Torah building is still standing; the below photograph shows how it looked in 1995. Public School No. 4, built across the street, took out an entire block of housing.

The Yavneh Academy was founded in 1942 as the Paterson Yavneh Yeshiva, initially meeting in Mandiberg's Delicatessen on Graham Avenue, pictured at left, with a kindergarten class of six students. The school later merged with the Talmud Torah and moved to 377 Twelfth Avenue. The Yavneh became a Jewish day school, combining religious instruction with secular education. In 1954, the school purchased the former Griggs estate, which was located across the street on Twelfth Avenue, and built new classrooms. In 1981, the Yavneh left Paterson for the suburbs. Yavneh Academy developed a national reputation among Jewish day schools for its innovative approach of combining Jewish and secular subjects. The building is currently used as a Paterson public school. Pictured below is a class from the 1960s.

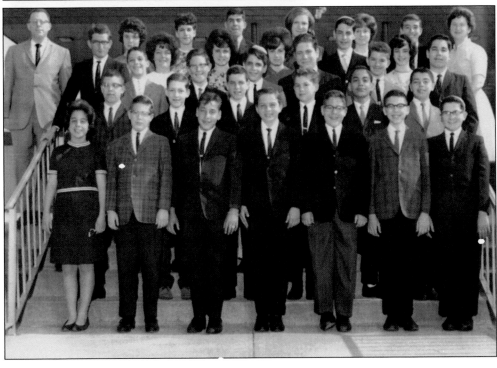

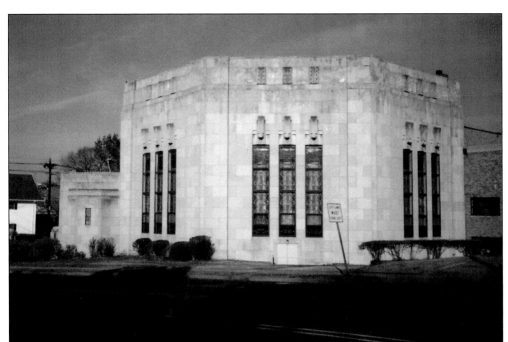

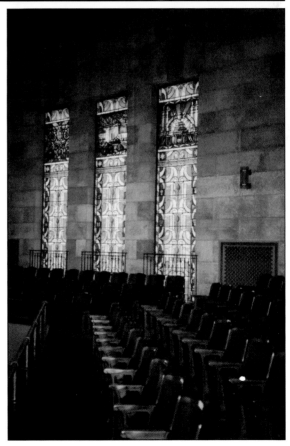

Temple Emanuel developed out of the First Austrian-Hungarian Benevolent Association in 1904, when the mutual aid society formed a congregation by holding services in an old church on Hamilton Street, then in a Bridge Street bakery, and later in the Masonic Temple on Broadway. By 1907, the congregation built a temple on Van Houten and Church Streets. The congregation outgrew this facility and moved to its newly constructed building on Broadway and Thirty-third Street in 1928. Jacob Fabian, a vaudeville and movie theater owner, donated the money and oversaw the construction. He hired Fred Wentworth, the famous Paterson architect, to design a magnificent synagogue to resemble his impressive movie palaces. Temple Emanuel affiliated as a Conservative Jewish religious institution. Connected to the temple was the Abraham M. Fabian Hebrew School, named for Jacob Fabian's son, who died at a young age. Like the members of Barnert Temple, Temple Emanuel's congregants moved out of Paterson, and the temple followed them to Franklin Lakes.

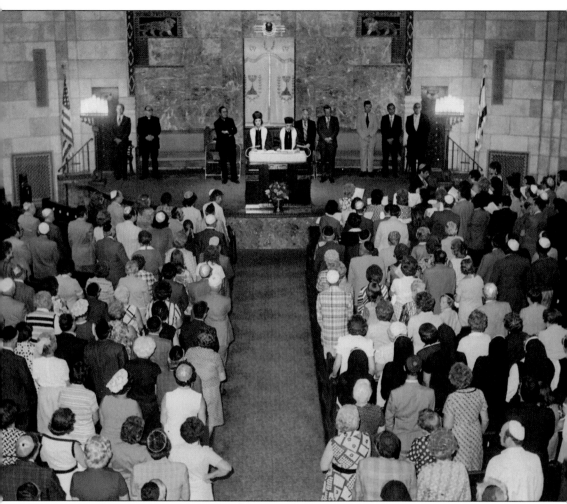

The interior of Temple Emanuel inspired awe because of its stained-glass windows and movie palace design. Pictured here is a memorial service for the Israeli Olympic athletes who were killed in the 1972 terrorist attack called the "Munich Massacre." Under better circumstances, this could be the scene of services during the High Holy Days. But the Munich attack was a traumatic event for Jews around the world, as the athletes had been targeted only because they were Israelis and Jews. Rabbi David Panitz is at the pulpit leading the service. Accompanying him on the bima are Catholic and Protestant clergy, temple board members, and Paterson mayor Lawrence Kramer (standing third from the right).

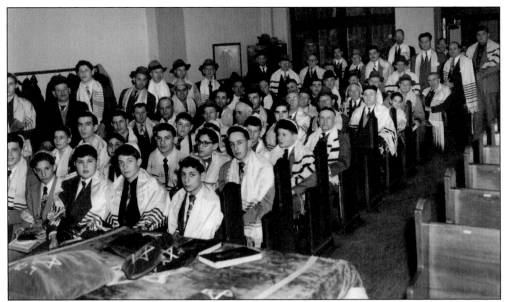

The side chapel in Temple Emanuel was used for morning and afternoon prayers and to accommodate overflow from the main chapel. The congregation's more observant members liked to pray together, and the smaller setting accommodated them. The chapel was the place where mourners could come each day to recite the kaddish, or mourner's prayer.

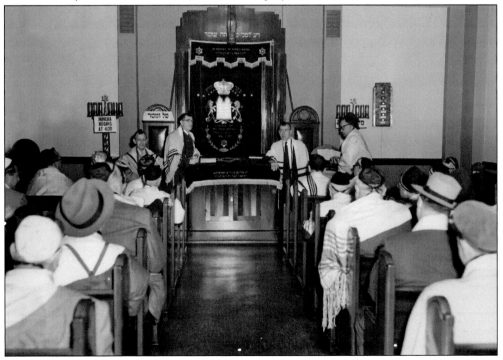

Israel Sarver (standing second on the right), the temple's shammes, or caretaker, led the services in the chapel. He could read Torah, fix the plumbing, unlock the doors, turn out the lights at night, and maintain order in the Hebrew school. He was also the rabbi's "front doorman," or majordomo, controlling access to the rabbi.

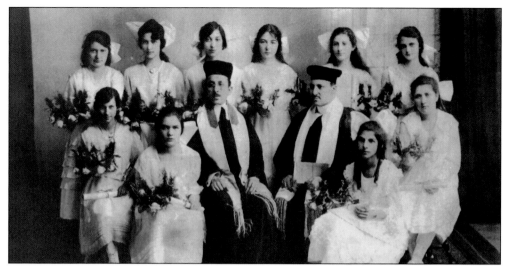

Temple Emanuel added the popular practice of confirmation to its religious education program. Posing for the first confirmation class are, from left to right, the following: (first row) Belle Friedenrich, Mildred Pilk, Cantor Capeles, Rabbi Lincoln, Edith Finkelstein, and Goldie Robbins; (second row) Helen Barth, Helen David, Ruth Newman, Eleanor Fabian, Edith Gross, and Edythe Kane.

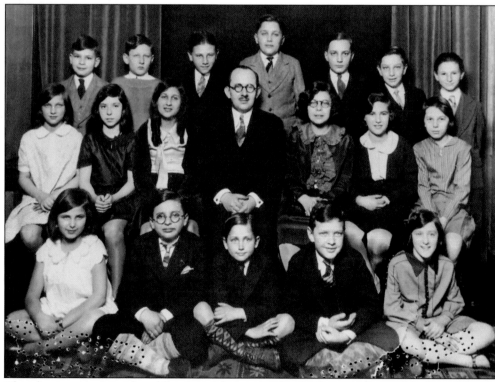

Choral groups were popular additions to religious services in Conservative and Reformed Jewish congregations. Cantors were recruited and hired for their knowledge, the quality of their voice, and their ability to lead and organize choral groups. Temple Emanuel's youth choral group from the 1930s is pictured here, with Cantor Martin Adolf in the center.

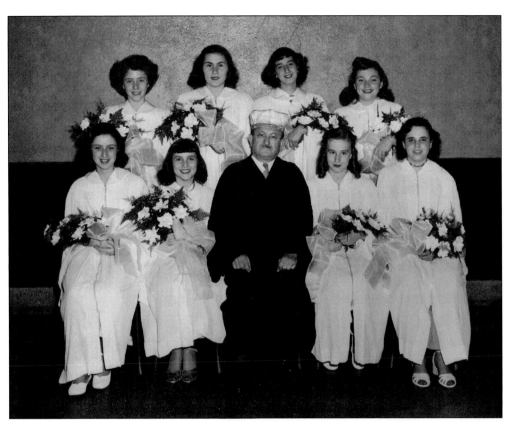

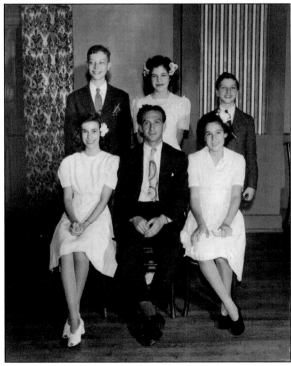

Temple Emanuel started a Hebrew high school program to provide advanced Jewish studies for interested students. These students moved beyond the rote learning of the Hebrew school to study Talmud and commentary and to continue Jewish learning beyond the bar mitzvah age of 13. This, along with the confirmation program, was part of a strategy to retain young Jews within the congregation while also giving religious instruction. Assimilation created competition for religious observance. The first class graduated in 1944 and is shown in the photograph at right. Seen are, from left to right, (standing) Marvin Cohen, Lois Rosenberg, and Jerry Gordon; (sitting) Lois Zelinger, Mr. Kartzinel, principal; and Barbara Stern. In the above photograph, Rabbi Reuben Kaufman poses with a Temple Emanuel confirmation class in the 1940s.

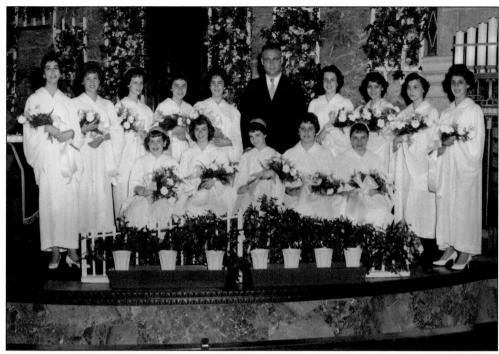

Shown wearing glasses in both photographs, Rabbi Arthur Buch supervised Temple Emanuel's confirmation classes in the 1950s. This program was geared to 16-year-olds, those beyond the bar mitzvah age of 13 years old. The bar mitzvah emphasizes individual responsibilities of membership. Confirmation studies, on the other hand, teach young adult Jews that they are entering "a sacred community," in which they can question, challenge, and debate Jewish doctrines without being judged. The confirmation model also encourages youth to work together as a community to contribute to the world around them. Confirmation classes generally adopt a *tzedakah* project, such as raising money to restore Torah scrolls. Thus, confirmation emphasizes the importance of communal participation in Judaism.

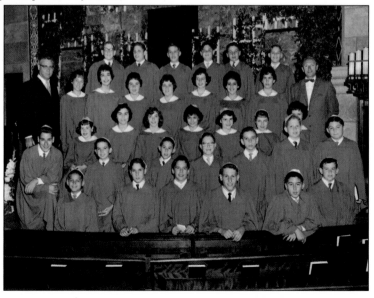

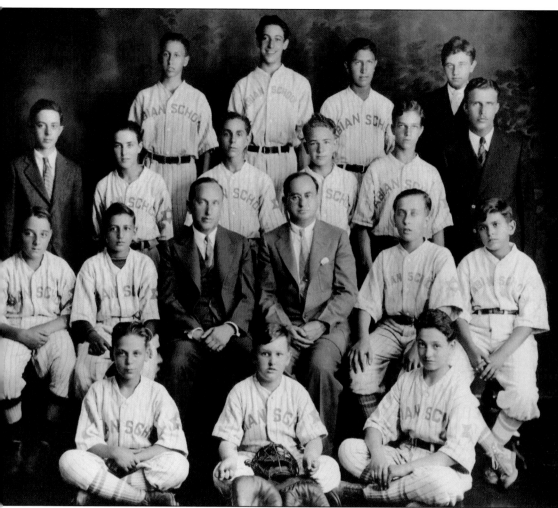

Temple Emanuel's Abraham Fabian Hebrew School had a baseball team in 1930. While the primary focus was always the teaching of Jewish prayer and ritual, fielding sports teams helped build community. Jacob Fabian, the major philanthropist at Temple Emanuel, was a visionary businessman who was very much attuned to American popular culture. He owned a series of movie theaters in Paterson and in other New Jersey cities. In the period when major Hollywood studios could own theaters, he had been an early partner of Warner Bros. And he was quick to realize the importance of baseball to American boys. After learning to read Hebrew together, playing baseball helped the students maintain a communal focus. Later, these students joined teams at the YMHA. Pictured are, from left to right, (first row) unidentified, ? Levine, and unidentified; (second row) Martin Herman, Leonard Garth, Charles Levine, two unidentified, and Edward Fabian; (third row) Irving Hershkowitz, unidentified, Alvin Krakower, Eugen Haubenstock, Jerome Schenker, and Sam Nochimson; (fourth row) three unidentified and Leonard Bluestein.

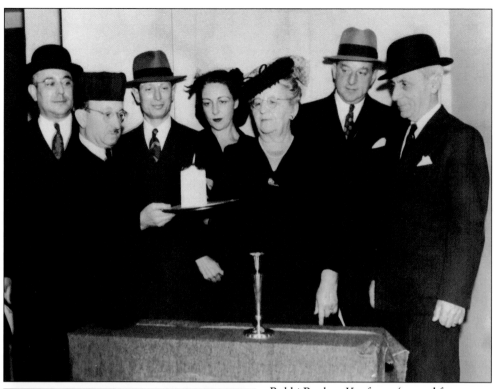

Rabbi Reuben Kaufman (second from the left) presided at the Temple Emanuel burning of the mortgage in 1940. Among those pictured with Rabbi Kaufman are Alvin Goldstein (far left) and Dr. Louis Shapiro (far right). This ritual celebration marked a major milestone for the congregation. Rabbi Kaufman left Temple Emanuel and formed a new congregation called Temple Beth-el.

David Panitz was the rabbi at Temple Emanuel from 1959 through the 1980s. He was a charismatic leader who was loved and respected by the congregation. He continued the emphasis of linking current events with religious practice, ensuring that the congregation focused on Zionism and the civil rights movement. He also encouraged the hiring of Israeli teachers in the Hebrew school.

Three

SILK MILLS

Jewish immigrants came to Paterson after 1900 to work in the silk mills. Skilled weavers came from Lodz and Bialystok. By 1913, over 5,000 Jewish men and women worked in the silk industry, with most working in broad-silk weaving. Jews owned or managed only a few small mills. When a bitter strike erupted, the Jewish textile workers joined Italian workers to fight for the eight-hour day and against the work speedup of the four-loom system, fines and penalties, child labor, and the blacklist. The strike was led by the "Wobblies," the International Workers of the World. Big Bill Haywood, Elizabeth Gurley Flynn, Carlo Tresca, Patrick Quinlan, and Adolph Lessig came to town as strike leaders. The strike attracted national attention through support of prominent writers and artists who held a huge rally in New York City in Madison Square Garden. The strike lasted six months, and the workers lost their attempt at reform. Large mills started moving to Pennsylvania and the South, but this became an opportunity for the Jews. Workers with an entrepreneurial spirit could rent space at the mills and run one or two looms, employing themselves and a few workers. World War I brought a lot of work to Paterson, as did World War II. This pattern lasted into the 1950s, until large-scale macroeconomic forces affecting textile manufacturing brought an end to the silk industry in Paterson. Yet, the years of labor struggle and risk-taking forged strong bonds of solidarity that only made the community healthier.

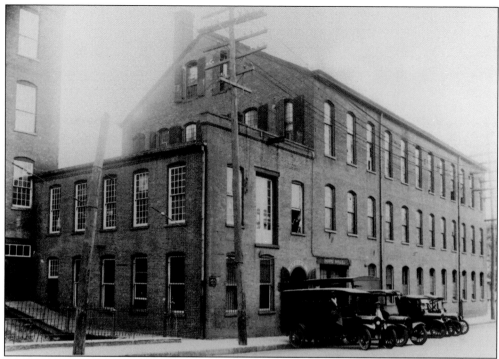

Brawer Brothers Silk Company was a large mill that had been founded by the Latvian-born Brawer brothers, who came to Paterson from England at the turn of the 20th century. They started as weavers working in a silk mill. They opened their own mill by borrowing from relatives and working on a small scale. Their business grew incrementally until it became a large operation.

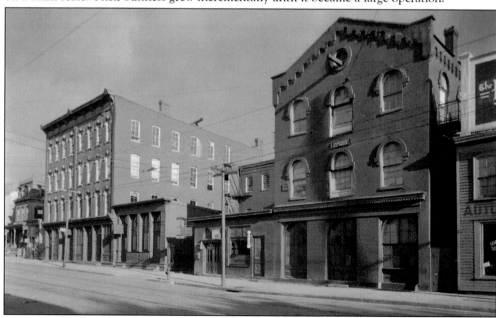

Paramount Silk Company was a medium-sized mill located on River Street. It ran its own looms but also rented out space to small one- or two-loom operations, which were known as "cockroach shops" because they "nested" in larger mills and closed off their space with chicken wire.

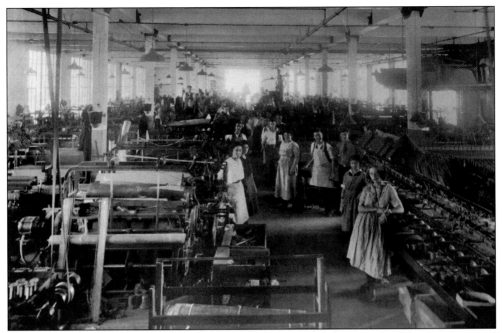

Silk mills were loud, dirty places filled with constant motion. The interior of this Jewish-owned mill gives some idea of the harsh working environment in which employees spent much of their days. (Courtesy of the American Labor Museum/Botto House.)

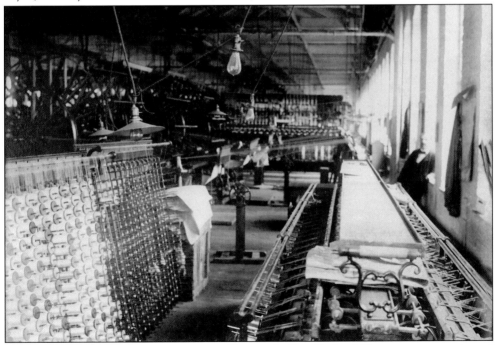

The Rosen mill gives another interior view of Paterson's silk mills. Jacob Rosen was an experienced manufacturer who built a business that would survive into the 1930s. However, the Great Depression wiped him out. He lost his major account with F.W. Woolworth and was unable to replace it with even small accounts.

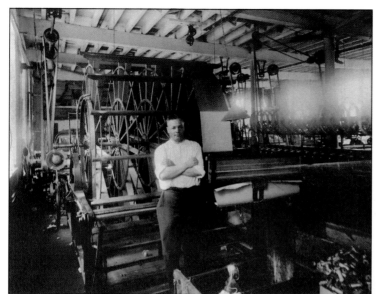

Joe Eisen came to Paterson as a weaver from Lodz in 1905. He started E&H Silk Company with his brother and uncle. Like many Jewish shops, it started as a family-run business, hiring other weavers when needed. Eisen closed his operation during one of the economic downturns.

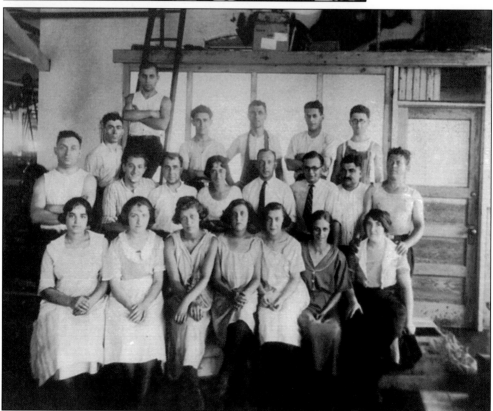

The Oppers and the Cohens joined forces to work their family-run silk mill. Shown here are, from left to right, the following: (first row) two unidentified people, Sade Opper, Mary Auerbach, Mary Opper, and two unidentified people; (second row) four unidentified people, Philip Bilsky, Nathan Wolf, an unidentified person, and Libel Opper; (third row) three unidentified people, Jacob Urback, and two unidentified people. (Courtesy of Roni Seibel Liebowitz.)

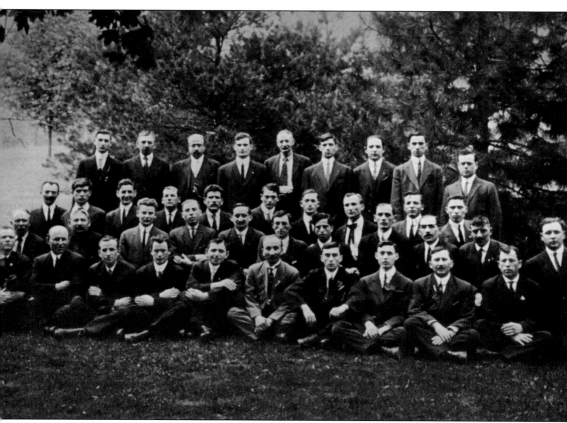

The 1913 silk strike pitted the workers against the owners, which should have been a fair fight. However, the owners hired strike-breakers and enlisted the help of the politicians who controlled the police. Most of the strikers were Jewish and Italian. The Jews were primarily weavers, while the Italians were dyers. Even though these two groups of workers did not speak each other's language and had different customs, the picket lines created strong bonds of solidarity that bridged these differences. Later, in the mixed Jewish and Italian neighborhoods in Paterson, these sentiments carried over. The grandchildren of these Jewish workers were not aware of the reasons for the solidarity. All they knew was that the old Italians were nice to them and very friendly with their grandparents. The group of Jewish strikers pictured here was arrested for picketing. They celebrated their release after serving 10 days in jail by going to the park for a picnic. To them, spending time in jail to improve their material lives and to maintain their dignity was a "badge of honor." (Courtesy of the American Labor Museum/Botto House.)

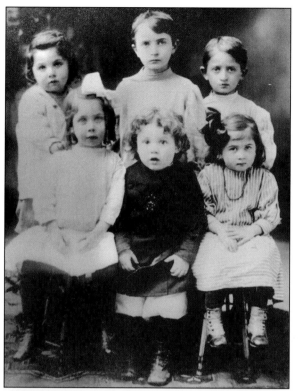

The silk strike of 1913 affected everyone in Paterson, not just the workers and the mill owners. Children acted as "runners" and translators. They carried instructions from strike headquarters to the picket lines and translated them for their parents. When Jewish strikers needed to talk to Italian strikers, their English-speaking children negotiated between the three languages. Because the strike lasted six months, some children were sent to relatives and supporters in New York and other cities. With no money coming in, the strikers could not feed their children. There were also lively debates among the more affluent teenage children in Barnert Temple. Some children of mill owners sided with the workers. The children in the below photograph are identified on page 43. (Photographs courtesy of the American Labor Museum/Botto House.)

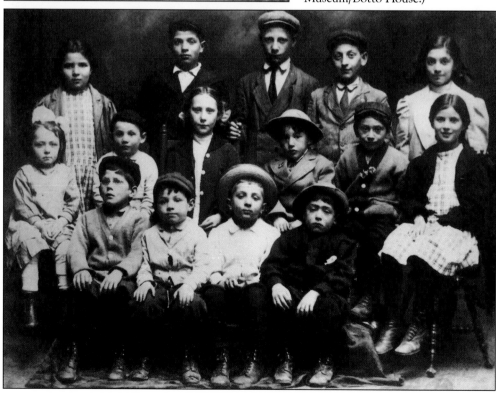

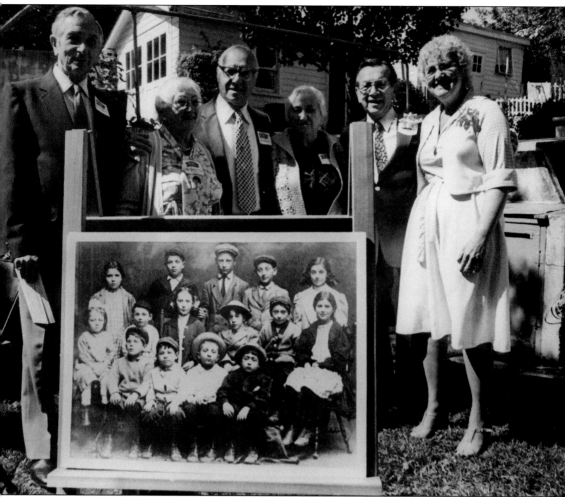

The American Labor Museum held a reunion of children of silk strikers. Shown here standing in front of a 1913 portrait are, from left to right, Paul Taub, Anne Janowitz Korn, unidentified, Rose Janowitz, Sol Stetin, and Sylvia Ferschein. The children in the original 1913 portrait are, from left to right, as follows: (first row) David Wenzowsky, unidentified, Charles Taub, and unidentified; (second row) Sadie Miller Cohen, unidentified, Sadie Wenzowsky Bernstein, unidentified, ? Abramowitz, and Ella Taub Dorfman; (third row) Anna Taub, Paul Taub, David Welsh, Isadore Abramowitz, and unidentified.

Jennie Mackler Sall (right) worked in the mills as a teenager in the early years of the 20th century. She became angry and offended by the harsh working conditions and low wages. She became a union organizer and was a firebrand. She was born in Bialystok, where her father was a professor of foreign languages. In Paterson, he became a disaffected silk weaver who was never satisfied with how fate had frustrated his career. Nevertheless, the family worked to insure that the children would get educations and move out of poverty. Her sons and nephews later became prominent doctors in Paterson. Some people mellow with age. Jennie Sall never changed. Late in her life, she moved to the Daughters of Miriam senior center, where she watched out for the rights of the residents and made sure the management provided the services that were promised in the service contract.

Four

BUSINESS

The Jewish formula for living and surviving in an adoptive country is to start a business. The German Jews who first settled in Paterson in the mid-19th century started as peddlers and eventually opened businesses in the downtown. Some became wealthy by later investing in manufacturing and in real estate. The Russian and Polish Jews who came after them in the 20th century followed the same pattern. Those without the highly sought weaving skills started out as peddlers and installment sellers, well-known occupations in the old country. They carried heavy packs on their backs throughout Paterson's neighborhoods. Later, they could afford to travel by horse and wagon, advertising their wares in a singsong voice. This was the "age of the man"—the iceman, coal man, seltzer man, dairyman, linen man, clothing man, and the scissors and grinder man. Many sold their goods on credit through weekly installments. Eventually, the peddlers became the merchants on River, Washington, Market, and Lower and Upper Main Streets. The streets were alive with people and merchandise of all kinds. At one time, a Curb Exchange operated at Washington and Market Streets in front of the Hamilton Trust Company. Jewish textile manufactures traded with each other in silk yarns and hired workers at the same time.

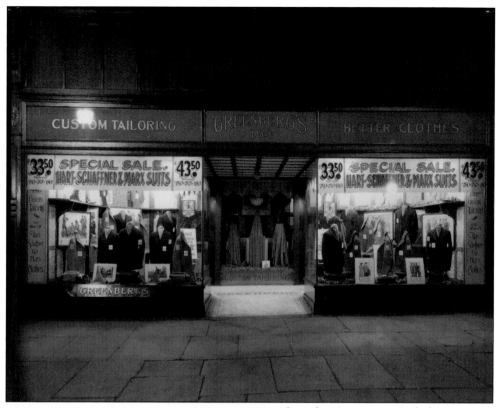

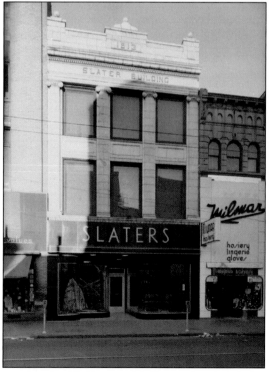

Greenberg's was a men's clothing store located at 194 Main Street. Besides selling suits from all the major clothing manufactures, Greenberg's had several tailors on staff who did alterations in the store. Greenberg's was a top choice of many of Paterson's business and professional class. (Courtesy of the Paterson Museum.)

Business owner Al Slater built his floor-covering store on Main Street in 1913. Slater was a major fundraiser for Jewish charities and was very active in the community. (Courtesy of the Paterson Museum.)

Looking east on Broadway toward Main Street are Reid Photo Studio; J. Mann, DDS; Star Carpet; T.R. Garland Wallpapers; Mildred's Dresses; and Sally-Ann Dresses. (Courtesy of the Paterson Museum.)

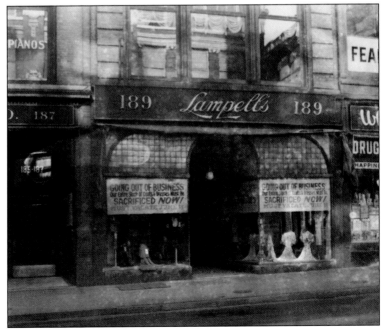

Lampell Millinery Co. at 189 Main Street went out of business in 1930. It was another victim of the Depression. (Courtesy of the Paterson Museum.)

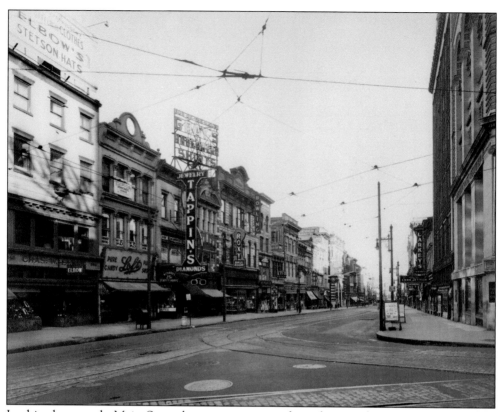

In this photograph, Main Street businesses are seen from the west from Market Street. The Jewish-owned businesses are the Charles Elbow Men's Shop, Larkey's Men's Shop, and Behrman Handbags. All of these establishments were owned by people who donated money to Jewish institutions and were active in the community. (Courtesy of the Paterson Museum.)

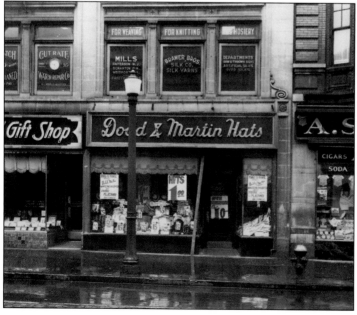

Dodd and Martin Hats was located at 132 Market Street, just off of the busy intersection with Main Street. This business also failed due to the economic downturn, and the stock was being liquidated by a receiver. This 1932 photograph shows the office of Brawer Brothers Silk on the second floor. It is interesting to note that Brawer Brothers had already moved part of its operations to Pennsylvania and to the South. (Courtesy of the Paterson Museum.)

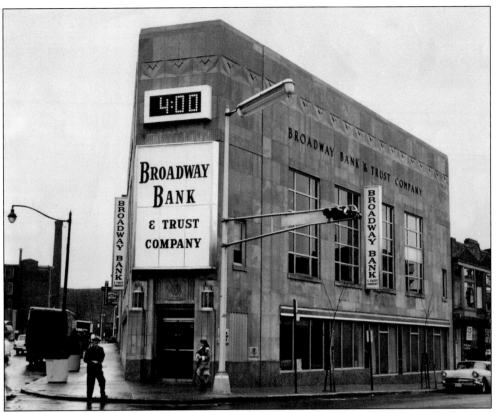

The Broadway Bank & Trust on Lower Broadway and Main Street was the gateway for this part of the downtown shopping district. Rent was cheaper than in the prime retail space farther up on Main Street. The Jewish businesses located here formed a type of informal association.

Located across the street from the bank were Silbersteins Curtains and the Port Arthur Chinese restaurant. Jews always had an affinity for Chinese food, and Port Arthur was a classic Cantonese restaurant that attracted downtown shoppers. (Courtesy of the Paterson Museum.)

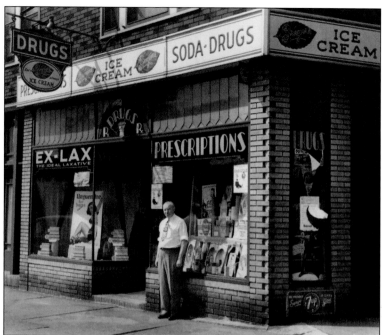

Morris Pinchak is shown standing in front of his Main Street pharmacy in 1945. He started the business in 1919. His son Frank, also a pharmacist, designed a drug bottle safety poster that was used in a national campaign sponsored by the federal government. (Courtesy of the Paterson Museum.)

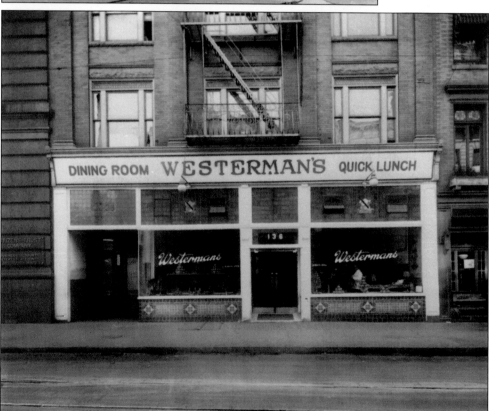

Westerman's restaurant was a popular lunch and meeting place on Broadway near Church Street. (Courtesy of the Paterson Museum.)

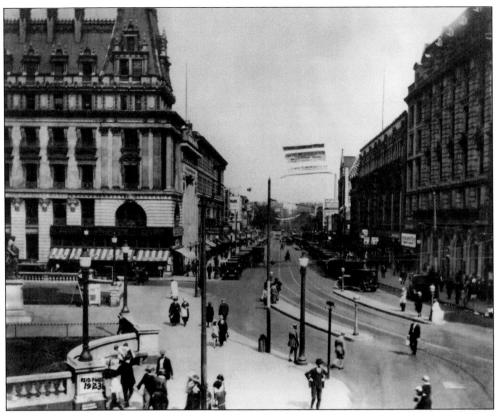

Market Street in 1923 was a busy commercial thoroughfare with many Jewish-owned retail businesses. The times were good, and many prospered during this period. (Courtesy of the Paterson Museum.)

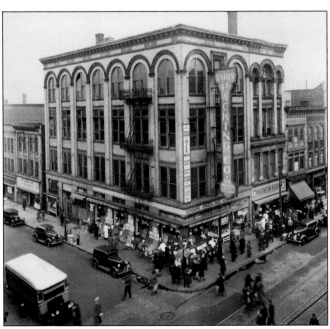

The corner of Washington Street and Broadway was a busy market. The street-level stores attracted a constant stream of customers throughout the day. The offices of the Silk Workers Union were located in this building. (Courtesy of the Paterson Museum.)

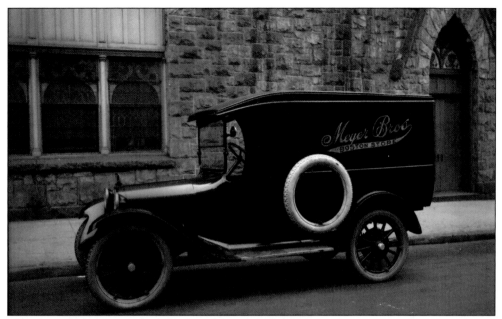

This photograph shows a Meyer Brothers delivery truck. Meyer Brothers was one of Paterson's largest department store. The marketing slogan from the 1960s, "Downtown Paterson has everything," was inspired in large part by Meyer Brothers' diverse and well-stocked store. Bertrum "Bert" Meyer was the owner and the public face of the department store. He was a prominent figure in Paterson's commercial history and is warmly remembered by former employees and customers as a true gentleman who really listened to people. He is also known for his extensive philanthropy. (Courtesy of the Paterson Museum.)

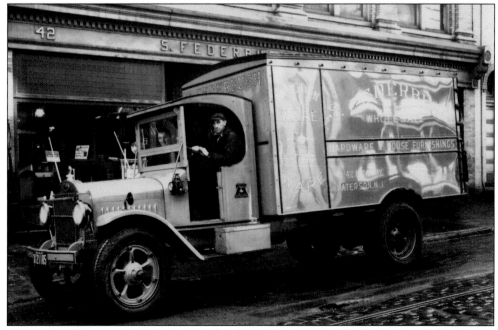

A Federbush delivery truck is shown parked at the establishment, at 40–42 Broadway. Federbush was the premier hardware and furniture dealer in Paterson. (Courtesy of the Paterson Museum.)

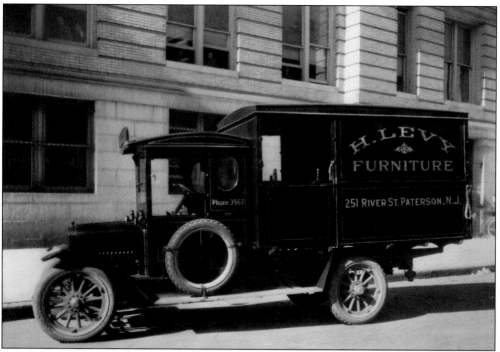

Shown here is a delivery truck for Levy Furniture, which was located on River Street. The store made deliveries to all of the neighborhoods and the surrounding area. (Courtesy of the Paterson Museum.)

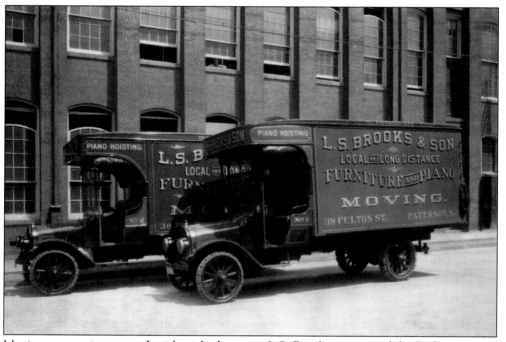

Moving companies were a Jewish niche business. L.S. Brooks was one of the leading moving companies in Paterson. Brooks family members, along with their Frishman cousins, helped their Rosenblum cousins to escape Nazi Germany in 1938. (Courtesy of the Paterson Museum.)

YOUR GROCER
THE CORNER DAIRY
CHAS. & HARRY BERKOWITZ
FANCY GROCERIES
BUTTER - CHEESE - EGGS
— WE DELIVER —
PHONE: LAmbert 3-8507 462 - 10TH AVENUE
PATERSON 4, N. J._____195__

M _____

✓ homo	1	20
1 rye mas	1	19
	2	84

General Printed Products Corp., 80 Washington St., New York 6, N. Y.

The businesses on Tenth Avenue were functional and utilitarian. They met the residents' everyday needs, so most were food stores. The Corner Dairy was a grocery store owned by Charlie and Harry Berkowitz. They sold milk, butter, cheese, canned goods, bagels, and Purity Cooperative rye bread. The New York Sanitary Meat and Poultry Market was a kosher butcher shop owned by Nathan Levine. There were several other stores along the avenue, such as a fish market, a few tailors, a shoe repair shop, and a barber. Irv Friedman's delicatessen and Richie's Chinese American restaurant covered most people's need for "eating out." Sussman's Drugs filled prescriptions, and Abe's candy store sold comic books and candy. Cohen's station pumped gas, and the Altshulers lived above their station. The people who lived above the deli and the Chinese restaurant were considered to be very lucky. People shopped downtown for clothing and larger household goods.

SHerwood 2-0888 All bills must be paid weekly
Paterson 4, N. J. _____ 195_

M _____

BOUGHT OF
New York Sanitary
Meat and Poultry Market
בשר כשר
MEAT, POULTRY, LAMB and VEAL
412 TENTH AVENUE
NATHAN LEVINE, Prop.

Sunday		5/ 00
Monday		
Tuesday		
Wednesday		
Thursday		
Friday	8 5 / 60	
	5/.00	

For Morning Delivery, Please Call Night Before

The Park Avenue business district was more diversified. Not only were there the usual groceries and drugstores, but there were also clothing and specialty shops. The New York Food Market sold fruit and produce. Sunshine's Delicatessen held down the corner at Thirty-third Street, and people came from all over the city to taste Harry Sunshine's pastrami, kosher salami, and to get a tip-of-the-tongue sandwich. Shulman's Produce was next door, and next to that were Maxim's, a specialty dress shop, and the A1 Market. Across the street was Ben and Bob's soda fountain, the neighborhood's meeting place. Then, there were Shamack's Drugs, Klein's Bakery, a fish market, a beauty parlor, and Jacob's Drugs. In another neighborhood, Aaron's Smoked Fish sold chubs, whitefish, salmon, sable, and, for an occasional special treat, sturgeon.

The kosher delicatessen is one of the most identifiable cultural items of American Jews. The deli defined the Jewish immigrant experience because dietary laws required Jews to eat only food that was kosher. Outside the home, this became problematic, and the delicatessen provided a solution. In Paterson, the delicatessens were not only restaurants that served Jewish specialties but also places that turned eating into a distinct social act.

The Jewish bakery is another distinctive cultural item defining the immigrant experience. Usually, baking was done in the home, but the bakery was the place for a real treat for very little money. The Eastside Bakery and Klein's baked cookies, charlotte russes, Russian coffee cake, and babka. The Purity Cooperative baked rye bread and rolls and then delivered them to all the groceries and markets in the Jewish neighborhoods.

Five

NEIGHBORHOODS

The German Jews who first settled in Paterson, near the Passaic River, later moved into the same neighborhood as Nathan Barnert. The Russian and Polish Jews first settled in the "over the river" neighborhood of North Main and Water Streets. They later spilled over to River Street and moved up the hill to Carroll Street and Graham Avenue. When their fortunes began to change and affordable housing opportunities opened up, they moved to the Eastside on the numbered streets, from Seventh Avenue to the area around Eastside Park. The stores really gave the neighborhoods a distinctive Jewish character. The signs of the kosher butcher shops had Hebrew lettering, and the delicatessens smelled of the pickles and drying salamis. Every neighborhood had its candy store with its own cast of characters who used the place as a hangout. The kids were in and out buying candy, looking at the racy covers of the paperback books, or playing the pinball machine. The "guys" spent their time in the back room playing cards or in the wooden phone booths placing bets on the horses. Housewives in the apartments talked to each other while they were hanging clothes on the lines running from their porches. The neighborhoods were like small towns.

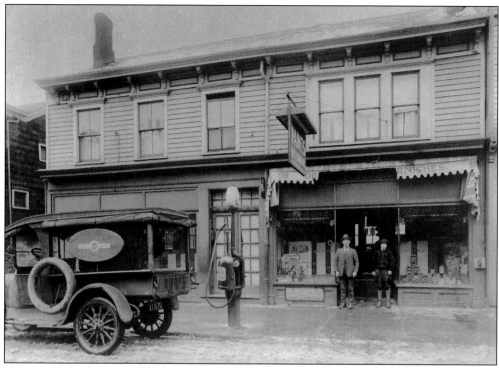

Harry A. Tribucher operated a paint and wallpaper store at 98 North Main Street. In the above photograph, Harry is seen standing next to his son Irving in 1919. In the 1930s, the business moved across the street because the City of Paterson wanted the building for the First Ward Public Library Branch. The business moved back to 98 North Main Street in the 1940s. Along with Harry's wife and sons, Donald and Irving, Harry Tribucher lived above the store until the 1950s. Standing in front of the neighborhood synagogue, the Water Street shul, are, from left to right, Michael Blumberg, unidentified, Harry A. Tribucher, and Meyer Garber.

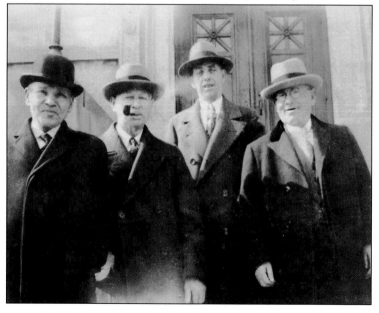

Bernard Abramowitz bought the pharmacy at 9 Bridge Street, shown the photograph at right, in 1923 from I.J. Mortimer Jacobs for $14,750. He operated the business until most of his customers moved out of the neighborhood. The pharmacist was more than someone who ran a business. He was a professional person who was an integral part of the community and backed up the doctors by explaining the treatment and sometimes offering an alternative solution. The immigrants relied on the pharmacist as someone who was, at times, more accessible than the doctor. In the below photograph, Emanuel Abrams, Bernard's son, is seen standing in the drugstore in 1926.

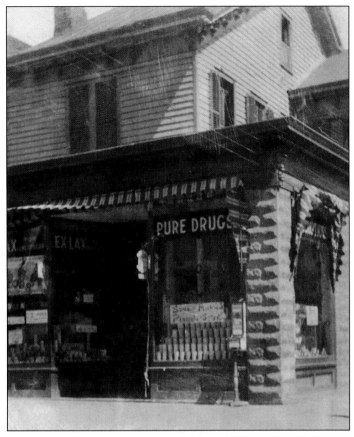

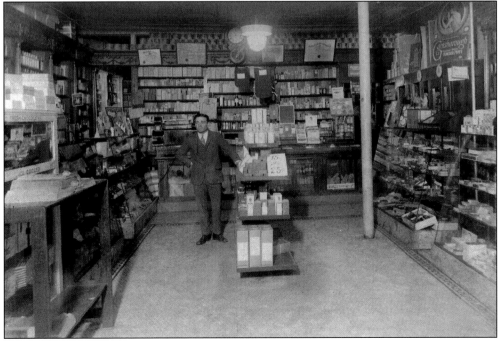

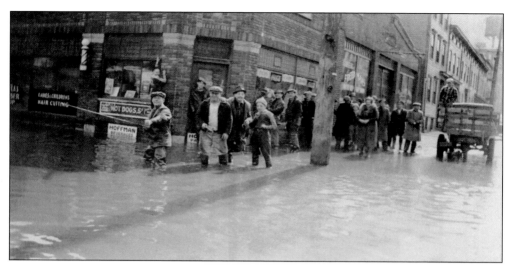

In the above photograph, the neighborhood gathers in front of the candy store on Water Street after the 1939 flood. This neighborhood suffered the most from the regular floods of the Passaic River. Everyone looks like he or she is enjoying the forced suspension of regular routines, which allotted them the opportunity to meet neighbors, swap stories, and cast a fishing line into Water Street. Farther down Water Street was the intersection with Holsman Boulevard (below). Before the urban blight and decay that afflicted Paterson in the 1960s, this was an active commercial district with stores, a popular restaurant, and apartments above the street-level establishments.

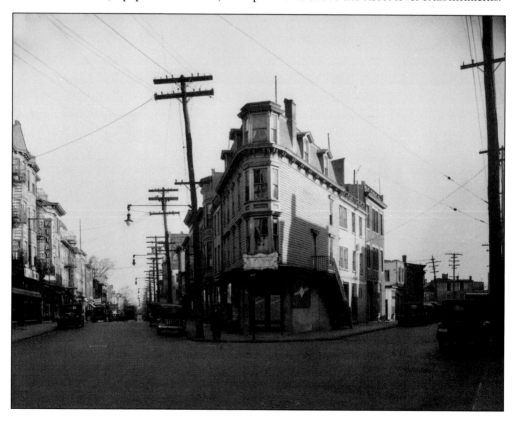

The Washington Street market bustled with activity and drew crowds of shoppers looking for fresh fruit and produce, live chickens, and notions. Typically, the merchants would jot the purchased items on a brown paper bag and add up the total. This was the receipt. The market was a transition point between downtown and the commercial district on River Street.

Jacob's Dry Goods Store started out on River Street, seen here in this photograph. It later moved to Lower Main Street and operated profitably for a long time. With the opportunity to purchase the much bigger Main Street store, Quakenbush's, Jacob's moved its operations there but kept the Quakenbush name.

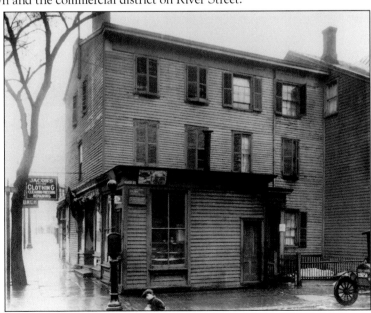

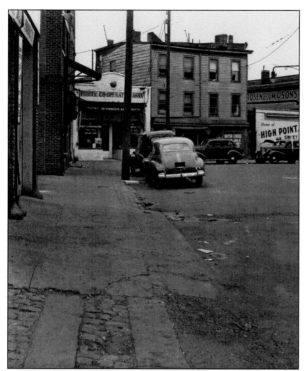

Shown here is Purity Bakery Cooperative on Tyler Street, next door to Rosenblum and Sons Dairy. In 1917, after the bitter silk strike, the Jews formed a cooperative bakery to ensure that people could buy food at affordable prices. A kosher butcher's cooperative was connected to the Purity. Initial shares cost $5, and when the cooperative dissolved in 1965, each shareholder received $25. The money was returned to be used by the community.

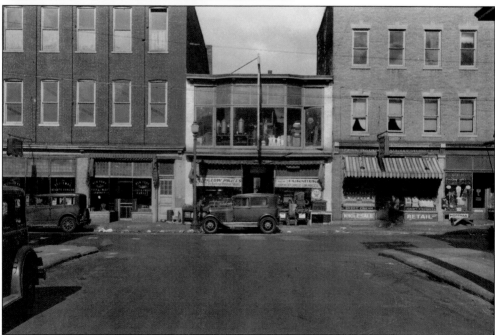

River Street is seen from the Purity Cooperative on Tyler Street. This portion of Paterson is now occupied by vacant lots. The once vibrant commercial district is a victim of urban renewal. The old structures were removed and replaced with public housing projects, unused lots, and city streets that lead in haphazard directions. Superimposing these photographs over the empty areas, it is possible to detect the old land use patterns.

Max Goldberg, a plumber, was born in Lodz and came to Paterson after his parents were killed during a pogrom in 1905. Here, he is standing with his wife in front of their shop at 15 River Street. There were not many Jewish tradesmen in Paterson, so Max was a familiar presence in many Jewish apartments and homes.

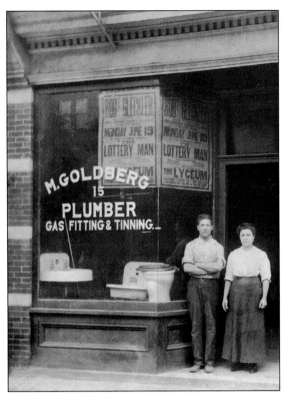

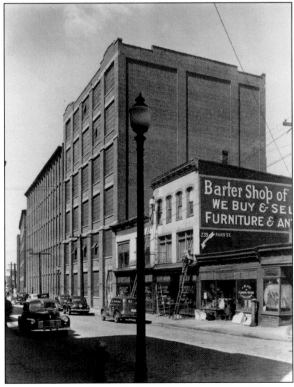

The Barter Shop at 239 River Street was a popular consignment store. People would bring in goods to sell, and if the item was sold, the shop paid out the amount minus a small commission. The Barter Shop also auctioned furniture and estates. The area depicted in this photograph is typical of a lot of Paterson land use patterns—a mixture of commercial areas with residential and manufacturing spaces.

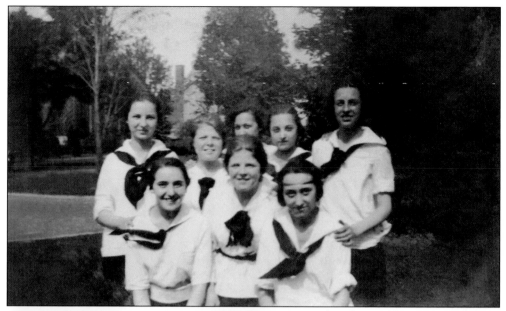

Dressed in their uniforms, these Carroll Street schoolgirls attended School No. 6. Directly after school, children would gather on neighborhood street corners with their friends before dispersing into smaller groups. Many schoolchildren remained friends for their entire lives, sharing all life-cycle events.

Eastside Park was a popular destination because of its gardens and wide-open fields, the latter a very scarce item in Paterson. Shown here is a School No. 6 class outing to Eastside Park. As a treat, the teachers arranged to move their students off of the asphalt playgrounds and allowed them to run free in a pleasant setting.

William Koggan owned the apartments on three corners at Eighth Avenue and Twenty-third Street. He was a builder who ran his real estate operations from a basement apartment in the building seen here. The neighborhood children called this the "animal house" because some of the tenants were named Wolf, Fox, Fish, and Katz, and several women were named Ceil.

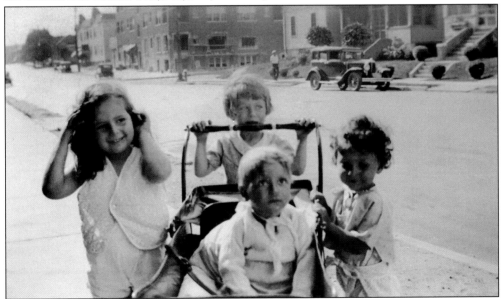

In this 1932 photograph, the Cohen children are on Eighth Avenue, visiting their cousins, the Simons. William Koggan's apartment is on the right. This neighborhood had a small commercial district, which later consisted of Harry Widedsky's grocery, Bernie Peres's candy store, and Frank's barbershop. The rest of the neighborhood was apartment houses, duplexes, and single-family houses, with several factories mixed in.

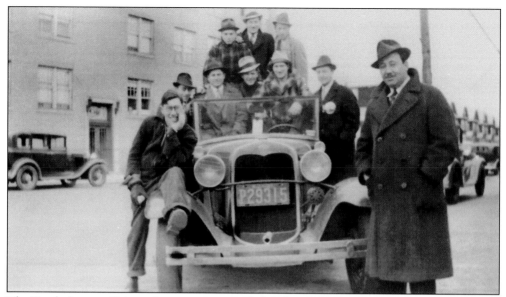

The Tenth Avenue Citizens League was a social club that turned a Tenth Avenue house into its headquarters. The men seen in this 1937 photograph at Cohen's gas station on Tenth Avenue grew up, raised their families, and did business together. Every afternoon, they retired to play cards together. Pictured here are, from left to right, (standing at back) Murray Richman, Ben Goldberg, and Sambo Cohen; (sitting) Maishe Lankind, Harry Guom, George Weiss, Lippy Rosen, Arthur Stein, and Joe Lankind; (standing by the fender) Larry Mendelson.

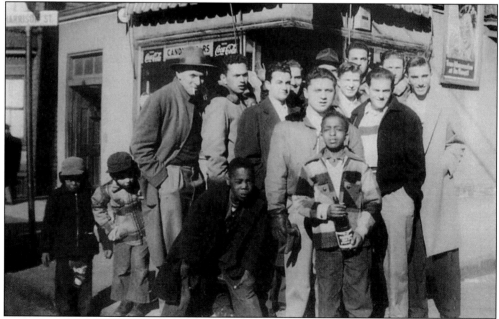

Aulee's candy store on the corner of Carroll and Harrison Streets was a hangout where people could buy candy, cigarettes, and newspapers. In addition to frequenting the soda fountain and pinball machine, people came to play pinochle in the back room or bet on the horses. Among those shown here are Aulee Kaufman (at left with hat and cigarette), Danny Epstein (at center wearing gloves), Herb Goldman (behind and to the right of Epstein), and Sid Cohen (far right).

The Cohen family lived on Eleventh Avenue. They had originally lived near Carroll Street but moved when an affordable opportunity came up on the Eastside. Ida Cohen was the home economics teacher at School No. 6, which was where she had attended as a child. Pictured here are, from left to right, Florence Greenbaum, Meyer Cohen, Marvin Cohen, and Ida Cohen.

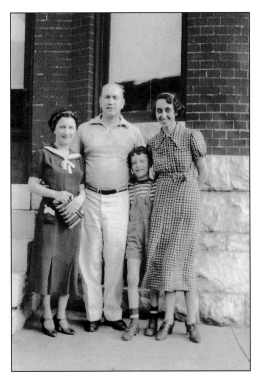

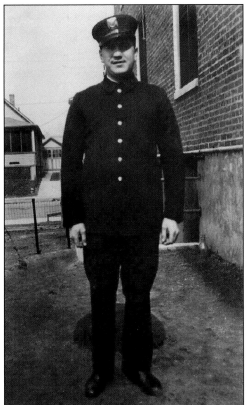

Meyer Cohen was a fireman at a time when there were very few Jews in the fire and police departments He spent over 30 years with the department and eventually worked his way up to the rank of fire captain. Meyer received several decorations for bravery. He was a valuable resource for his Jewish neighbors and could provide them with difficult-to-obtain official information after a fire.

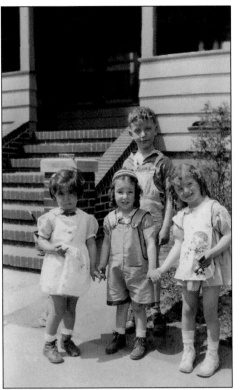

Children from Eleventh Avenue are seen here playing outside. These were much different times from today because even very young children could be outside without direct supervision by their parents. Neighbors could be trusted, and someone was always loosely watching over the children. Marvin and Abby Cohen (center) are standing in front of their apartment house with two neighborhood playmates.

David Greenberg and his son Murray had extensive real estate holdings throughout the city. They lived by Eastside Park. He was very active as a fundraiser for Jewish charities. He spent the entire decade of the 1930s rescuing his relatives still living in Hungary from the Nazis. He arranged jobs and apartments in Paterson to get them started. From left to right are Daisy, wife; David; and Daisy's sister.

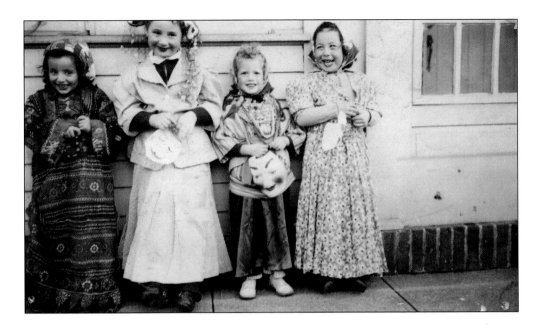

Halloween was always a big event in Paterson's neighborhoods. It was just as much fun for the adult neighbors as it was for the children. Here is a group who lived on East Twenty-fifth Street and Eighth Avenue in 1944. Even though World War II was still going on, the only battles here were between older and younger siblings over candy. One of the neighbors around the block owned a candy store. This was the most popular stop because the proprietor gave the children comic books instead of candy. Another Paterson tradition was "goosey night." The night before Halloween, teenage boys would soap up the windows of cars and stores. This was also the time to even the score with cranky or ill-tempered neighbors.

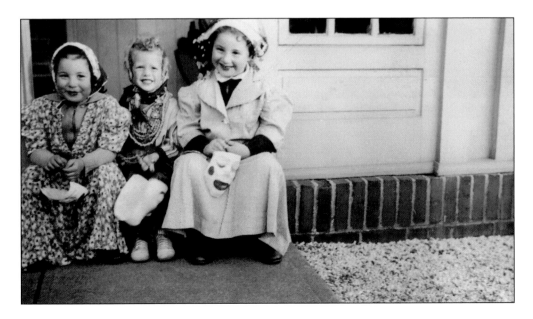

Rose Rosen Douma, shown here in 1944, lived and raised her family on East Twenty-fifth Street. She was born on Bridge Street, moved to Harrison Street, and eventually her parents bought a house on Ninth Avenue. When older, all of her brothers and sisters and their families lived within walking distance from each other, so they visited each other daily. Rose was active in B'nai Brith and the PTA.

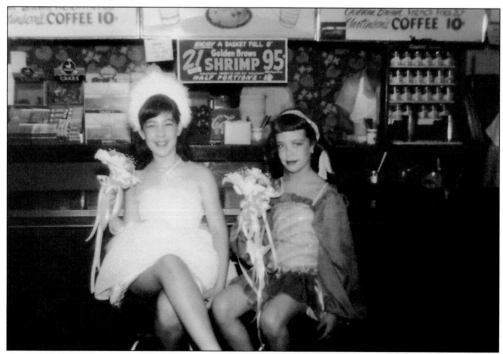

Vivian Taub (left) and Roni Seibel are seen here celebrating at Toby's after a Jackie Donovan dance recital in 1950. Vivian Taub's father owned Toby's, located on McLean Boulevard. Toby's was a hot dog stand, soda fountain, and neighborhood hangout. Generations of Jewish girls learned the art of modern dance at the Jackie Donovan dance studio. (Courtesy of Roni Seibel Liebowitz.)

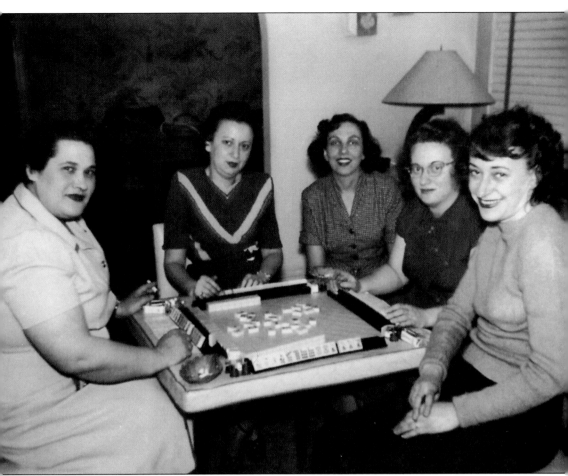

These women, who lived near Tenth Avenue, were lifelong friends. They held a mah-jong game that rotated each week among their homes. The game was important to them but was secondary to their socializing and exchanging news about their families and the neighborhood. Being the hostess was a form of expression. She could showcase a new recipe or just gain pleasure from extending hospitality to her friends. Groups of women like this shared all of their life experiences with each other. Together, they went through their pregnancies, raised their children, married off their children, and derived *naches*, a sense of pride and pleasure, in fulfilling their life's role through their grandchildren. Their friendships meant that it was very likely that their husbands and children were friends, too. If there were a crisis situation, they were ready and able to help or provide support. Pictured here are, from left to right, Betty Marcus Seibel, Doris Lansen, Thelma Auerbach Seibel, Rosie Rothenback, and Lil Berkowitz. (Courtesy of Roni Seibel Liebowitz.)

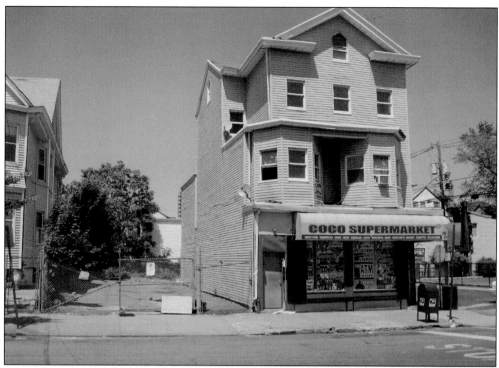

Seen in this 2012 photograph, the alley on the side of this building was the path to Cohen's Hamilton Avenue bagel bakery in the back. People remember walking through this alley at night, smelling the bagels and meeting friends. On Saturday nights, there was always a long line. At that time, a dozen bagels cost 60¢, and the choices were plain, poppy seed, or onion. Cohen never revealed his recipe.

The point at Water Street and Holsman Boulevard, shown here in 2012, looks quite different than the 1920s view of the intersection on page 62. What was once a bustling commercial hub that supported a neighborhood of shops and residences is now a blighted area of rundown housing, garages, and storage lots.

Six

MEDICINE

Before medicine became a multibillion-dollar-a-year business, hospitals were a true reflection of the community they served. Traditionally, they were sponsored and managed by religious communities like the Catholics and individual Protestant churches. Being a Jewish hospital patient in the early 20th century was problematic. Jewish doctors rarely had hospital privileges, making it difficult to get their patients admitted. Even if a Jewish patient got into a hospital, they could not eat the food since it did not conform to the special religious and dietary requirements of Jews. In Paterson, Nathan and Miriam Barnert attempted to solve this problem in 1908 by funding a Jewish dispensary and clinic at 56 Hamilton Street. Soon, however, demand overwhelmed this clinic, and in 1911, Barnert arranged for the purchase of the Crosby estate on Paterson Street, a bigger facility. Even this clinic could not serve all of the Jewish patients needing hospital care. Barnert deeded the land at Broadway and Thirty-first Street for a new hospital. He enlisted Jacob Fabian, who donated the funds to finance and oversee the construction. Work started in 1914, and in 1916, the Barnert Hospital opened its doors to serve primarily the Jewish community but as well as people of all faiths. Barnert Hospital operated for 99 years before it was converted into a medical office building and clinics. The doctors who practiced there were an integral part of the Jewish community. Many were the sons and daughters of the old immigrants. Some even financed their medical educations by working in the silk mills, and by doing so, their life experiences were not very different from their patients. Albert Sabin, who discovered the polio vaccine, grew up in Paterson, though he practiced medicine elsewhere. Irving Selicoff practiced in the Paterson Clinic while he isolated the causes of asbestosis and developed its treatment, a major public health breakthrough.

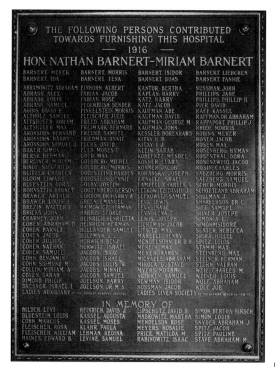

THE FOLLOWING PERSONS CONTRIBUTED
TOWARDS FURNISHING THIS HOSPITAL
— 1916 —
HON. NATHAN BARNERT—MIRIAM BARNERT

| BARNERT, MEYER | BARNERT, MORRIS | BARNERT, ISIDOR | BARNERT, LIEBCHEN |
| BARNERT, IDA | BARNERT, TENA | BARNERT, BOAS | BARNERT, FANNIE |

ABRAMOWITZ, ABRAHAM	EINHORN, ALBERT	KANTOR, BERTHA	NUSSMAN, JOHN
ABRASH, ALEX	FABIAN, JACOB	KAPLAN, HARRY	PHILLIPS, JANE
ABRASH, LOUIS	FABIAN, ROSE	KATZ, HARRY	PHILLIPS, PHILLIP H.
ABRASH, SAMUEL	FEDERBUSH, SENDER	KATZ, JACOB	PIER, DAVID
ADINS, DAVID B.	FINKELSTEIN, MORRIS	KAUFMAN, ABE	RAFF, KASSEL
ALTHOLZ, SAMUEL	FLEISCHER, JULIE	KAUFMAN, DAVID	RAFFMAN, DR. ABRAHAM
ALTSHULER, ABRAM	FREED, ABRAHAM	KAUFMAN, GEORGE M.	RAPPAPORT, PHILLIP J.
ALTSHULER, MAX	FREIMARK, BERNARD	KAUFMAN, JOHN	RHODE, MORRIS
ARONSOHN, BERNARD	FREUND, SAMUEL	KESSLER, BORENHARD	ROBINS, MEYER
ARONSOHN, HARRY	FRIEDMAN, ANNIE	KITAY, H. B.	ROSEN, JACOB
ARONSOHN, SAMUEL J.	FUCHS, DAVID	KITAY, I. J.	ROSEN, MAX
BAKER, SIMON	FELD, MOSES I.	KLEIN, SARAH	ROSENBERG, HYMAN
BERSH, HERMAN	GOLD, MAX	KOBLENTZ, MENDEL	ROSENTHAL, DORA
BERLINER, MIRIAM	GOLDBERG, MICHEL	KONNER, CLARA	ROSENZWEIG, JACOB
BINGE, SIEGFRIED	GOLDBERG, MORRIS	KONNER, JACOB	ROSIN, CHARLES
BLITZER, CHARLES	GOLDSTEIN, CHARLES	KORANSKY, JOSEPH	SALZBERG, MORRIS
BLOOM, EDWARD	GOLDSTEIN, JENNIE	KRAVITZ, ISRAEL	SALZBERG, SAMUEL
BLUESTEIN, DORA	GOLDY, JOSEPH	LAMPELL, CHARLES S.	SCHER, MORRIS
BORNSTEIN, BARNET	GOOTENBERG, GERSON	LEEKOWITZ, DAVID J.	SCHOTTLAND, ABRAHAM
BRAWER, ARTHUR	GORDON, DR. HARRY A.	LEFKOWITZ, SAMUEL	SHULMAN, A.
BRAWER, LOUIS H.	GREEN, EMANUEL	LEVI, LEWIS	SHNAYERSON, DR. L.
BREZIN, WALTER I.	HAIMOWICZ, HERMAN	LEVY, ISAAC	SIEF, SAMUEL
BRICKS, JOHN	HARRIS, GEORGE	LEVY, LENA I.	SILVER, JOSEPH
CHARNEY, JOHN	HEINRICH, HENRIETTA	LEWIS, JOSEPH	SIMON, A. L.
COHEN, ABRAHAM D.	HEINRICH, HERMAN	LICHTMAN, JACOB	SIMON, ISIDORE
COHEN, BARNET	HOLLANDER, SAMUEL	LIFSITZ, MAX	SLATER, REBECCA
COHEN, JACOB	HOLZMAN, S. L.	MARELLI, HENRY	SPIRA, HILLEL
COHEN, JULIUS	HORWICH, BENJ.	MENDELSOHN, DR. D. H.	SPITZ, LOUIS
COHEN, NATHAN	HORWITZ, ISRAEL	MENEIN, MAX	STAMM, MAX
COHEN, SAMUEL	JACOBS, ISAAC	MEYER, AARON	STEINBERG, MAX
COHN, BENJAMIN	JACOBS, ISRAEL	MICHAELS, ABRAHAM	STEINER, HERMAN
COHN, SIGMUND M.	JACOBS, LOUIS W.	MIKOLA, GUSTAVE	STERN, NATHAN
COLLIN, MIRIAM A.	JACOBS, MINNIE	MYERS, MORRIS	WEIL, CHARLES M.
COVEN, SARAH	JACOBS, SAMUEL	NDINKEN, SAMUEL	WEINER, LOUIS
DIMOND, PHILIP	JOELSON, HARRY	NEWMAN, ISIDOR	WOLF, ABRAHAM
DRESNER, ISRAEL I.	JOELSON, DR. M. S.	NUSSMAN, JACOB	WOLF, JOE
LADIES AUXILIARY of the Barnert Memorial Hospital		LADIES LINEN SOCIETY of the Barnert Memorial Hospital	

IN MEMORY OF

BILDER, LEVI	HEINRICH, DAVIS J.	LIPSCHUTZ, DAVID S.	SIMON, BERTHA HIRSCH
BLUESTEIN, LOUIS	KASSEL, AUGUSTA	MASKOWITZ, MARTHA	SIMON, LOUIS
COHN, MARCUS	KASSEL, MOSES	MENDELSON, ROSE	SNYDER, ABRAHAM J.
FLEISCHER, ROSA	KLAHR, PAULA	MEYERS, ROSALIE	SPITZ, JACOB
FLEISCHER, WILLIAM	LEHMAN, REGINA	PRICE, MATILDA M.	SPITZ, PAULINE
HAINES, EDWARD B.	LEVINE, SAMUEL	RABINOWITZ, ISAAC	STAVE, ABRAHAM M.

The names on the dedication plaque for Barnert Memorial Hospital are a list of the largest businesses and professionals within the Jewish community in 1914. It was a true community-wide effort that succeeded in raising the funds for this large-scale construction project. What began in 1908 as the Jewish Dispensary became a communal hospital in 1916.

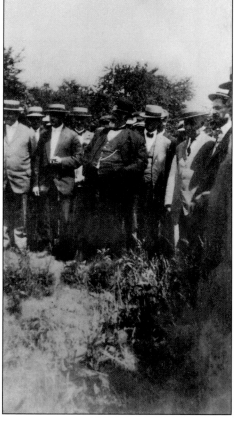

Nathan Barnert, in another act of generosity, deeded 16 parcels of land at Broadway and Thirty-first Street and $450,000, for the hospital. Barnert (center) is pictured here at the ground breaking with Jacob Fabian and the other members of the building committee. Fabian had also donated a large sum of money and oversaw the construction.

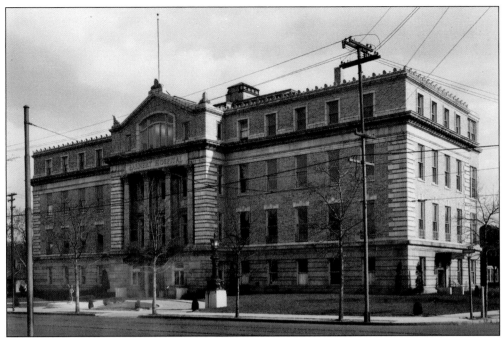

The hospital was an impressive product of the entire Jewish business and professional community, led by Nathan Barnert and Jacob Fabian. Fred Wentworth, the architect for Fabian's movie theaters, designed the building. Built specifically to serve Jewish patients, the hospital maintained a kosher kitchen and had a special room designed to be a chapel. The surrounding neighborhood, undeveloped at the time of the hospital's establishment in 1914, became the location of medical offices, and doctors chose this desirable neighborhood for their homes. Temple Emanuel would be built several years later two blocks from the hospital.

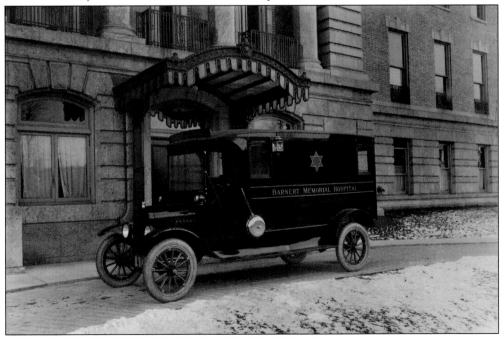

Many of the doctors who practiced at Barnert Hospital were Paterson natives who started there during their residencies. Pictured here in the 1930s are, from left to right, the following: (first row) Drs. Philip Opper and Meyer Mackler; (second row) Dr. Theodore Bender, the chief of medical staff; Drs. Maurice Shinefeld, Bernard Halpern, Irving Halpern, and Louis Roth, the hospital superintendent.

Robert Joelson (first row, third from left) is pictured here with the other Barnert Hospital interns in 1950. Robert was Dr. Morris Joelson's son. In addition to practicing medicine, Robert was a musician and a photographer. He performed frequently for his colleagues at Barnert Hospital and displayed his artwork in numerous galleries.

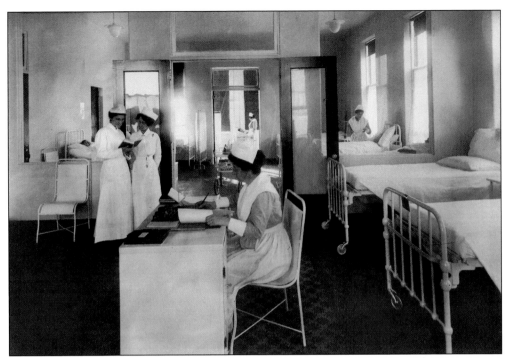

Barnert Hospital nurses are seen working on the ward in the 1920s. Many of the nurses came directly from Paterson's Jewish community, meaning they knew many of the patients. The stress of a hospital stay was mitigated in part by being cared for by nurses who were neighbors, relatives, or friends.

Barnert Hospital had its own three-year nursing training program, which was an important career path for Jewish women. The 1942 nursing graduation class posed for this photograph before many of them were sent to Europe and the South Pacific to staff field hospitals during World War II.

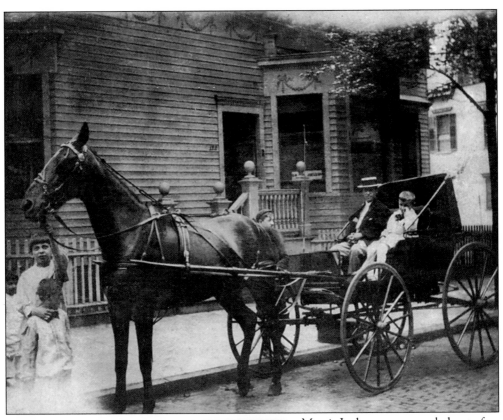

Morris Joelson was smuggled out of Russia hidden in a pickle barrel as a child. He worked as a mill hand to earn money for his family. They in turn united to support him through medical school. On house calls, he made a quick assessment of the family's circumstances. If they had the means, he collected his fee. If they were poor, he usually left $10 tucked under an ashtray without saying a word. Jewish parents in Paterson exhorted their children to act like a mensch, a righteous person. They underscored their point by saying, "Be like Dr. Joelson." The above photograph shows Dr. Joelson in his buggy with his son.

I Remember . . .

by DR. M.S. JOELSON

You ask me to write about my most interesting case, and I say I can't. There is no one instance to head my list; rather are there many things which stand out in my mind as I remember my forty-six years of practice.

I remember Paterson when it was just beginning to grow ---- when a twelve year old immigrant boy could find work in a rich man's factory, and so help support his sisters and brothers with his $2 a week. I remember a daily 15 cent allowance for lunch during medical school days, and I have a heartburning sensation every time I recall the beans which were my daily lot. For the price of a beer a man could put away a magnificent free lunch, but this fool couldn't develop a taste for beer!

I remember the days of the horse and buggy, and the pride I took in mine. The first automobiles come to mind, and the snapshot in everyone's album of FATHER standing proudly beside the fabulous new horseless carriage. I think back to the blizzards of those "good old days," when a Dynaflow Buick would have been most welcome as I tramped through the snowy streets that neither horse and carriage nor horseless carriage could navigate. I remember the epidemics, of proportions now almost unbelievable.

But most of all, I remember the people. I remember the woman who had long since despaired of having children, being safely delivered of triplet girls. Just making up for lost time, I guess! And I remember the three sets of twins born on three successive days. I remember the man, newly arrived in this country, treated without charge when he was down, who showed his gratitude time and again when he set up his own business by supplying me with any needed items

he had available. How did he know what I needed? On his own, he checked my office periodically and the necessary articles appeared like manna from heaven. I remember the evening during a flu epidemic, when an urgent call brought me to a Main St. address. I walked up three flights of stairs, only to walk in on a poker game. At first I thought it was a wrong number, until one of the men stood up, peeled off his shirt, and said, "OK, Doc, I want a thorough examination." That guy I'd like to forget.

Then there was the woman who called at 4 a.m. to tell me the baby was normal now ---- could she have the 2 inches of banana? The bright youngster, the four year old genius in spelling, also comes to mind. "Melvin," says the mother, "Show the doctor how smart you are. What spells M-I-L-K?" And quick as a flash Melvin replies, "Soldier!" I understand he's a Colonel in the Air Force now.

One of my most loyal patients is the woman who always calls me for advice ---- on any matter. On one occasion she slipped while getting on a bus and bruised her hip, and of course followed her arrival home with an immediate phone call describing the accident. Should she put anything on it? "Just cold compresses," said I. "Why cold?" she asked. My patience (you have to have that kind, too) was wearing a bit thin, but I answered softly, "Because cold compresses will help the bruise and the swelling." "Cold, you say?" "Yes, cold," I replied. "OK," my lady answered, "So I'll put hot." I never knew her to TAKE my advice, but she was very faithful about asking for it.

One of my most vivid memories concerns a particular day, already busy because of a diptheria epidemic, when I found myself with seven potential maternity cases in labor at the same time. For these deliveries I had to go on foot, for that was the day three young whippersnappers, decided to steal my car for a joy ride.

The early days were always full of emergencies, it seems to me. Everyone needed a doctor immediately. Especially the man who virtually tore down my office door in his excitement, shouting, "Doctor! Doctor! Come in advance! My wife is kidding!" Believe me, HE wasn't. I arrived on the scene in time to welcome into the world 9½ pounds of first generation Patersonian, destined to grow up to share the same privileges as the descendants of Alexander Hamilton himself.

I remember too a low point in my career, when I visited one of my first patients to find that she was in the midst of her bed bath. I was asked to wait outside, which I did, finally to be summoned by the nurse, calling, "Alright, little boy, you can go in to see your mother now." Crestfallen, but still undaunted, I informed her that I was the doctor, then drew myself up to my full height and marched into the room.

Forty-six years is quite a span. Ladies' skirts and ladies' hair styles have gone up and down many times. Prices seem to go in only one direction. Things are easier now for our women, what with mechanical devices in the kitchen and new drugs and procedures in the hospital. Strangely enough, though, the women don't seem to me to have changed much. They still call to say the baby's nose is running --- what should they do? What can I tell them? "Wipe it!"

They still get upset when their six month old babies won't eat on schedule. What can I say? "Don't worry --- in five years he'll be going to school, and EVERY day he'll be home for lunch at 12 o'clock."

Yes, time has passed, and now my babies are having babies. But to me each baby is different. Each one an individual personality. And their mothers --- changing but unchanged --- still look good to me. From any angle.

Morris Joelson wrote a memoir for the Barnert Memorial Hospital Newsletter; it is shown here and sums up his career as a doctor in Paterson.

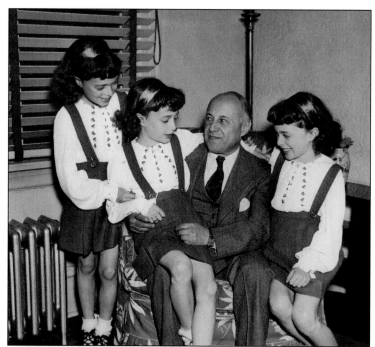

Dr. Morris Joelson delivered over 10,000 babies. He knew and remembered every mother and every child he delivered. Spending any amount of time with Dr. Joelson was a special experience. Early in his career, he was a general practitioner who visited Paterson's neighborhoods, treating patients during the many epidemics of the early 20th century. He is pictured here with the Pomerance triplets, Barbara, Joyce, and Sheila.

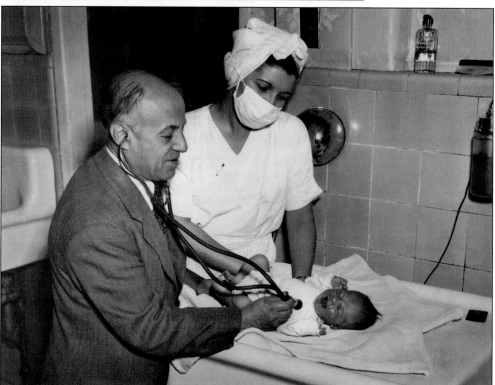

Dr. Joelson not only had a good bedside manner with his patients, but his nurses also idolized him. He was short in stature but never carried on like Napoleon. He was always soft-spoken and humble. He, as well as his nurse, is pictured here just after a delivery in Barnert Hospital in 1946.

Seven

SCHOOLS

Paterson's Jews started to learn to be Americans by attending public schools. It was not just the civics lessons but also the sustained social interaction with children from different religions, national backgrounds, and races. Then, there was the modeling behavior of watching one's teachers—adults who were not parents or family. This was as true in the 1970s as in 1906 and every period in between. While not different from those in other cities, the Paterson public schools were neighborhood schools. All the children from the same area in the city attended together. This included older and younger siblings. It was not unusual for one class to consist of the brothers and sisters of people in another class. This continuity helped the teachers and then helped the parents who organized in the PTA. It was another tie that bound people together, along with those of neighborhood, family, synagogue, business, and voluntary associations. Special note should be made of the teachers. The Jewish and Italian teachers were often the children or grandchildren of the immigrant silk workers or businessmen of small operations. Their life experiences were not much different than those of their students and their parents. And since many lived in the same neighborhoods, there were no gaps in communication due to formal roles.

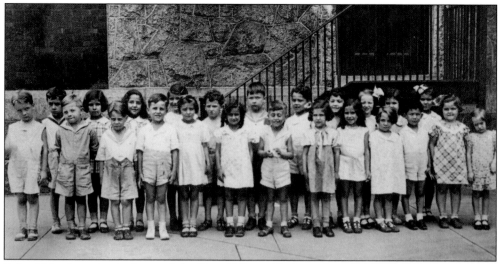

School No. 6 was in the heart of the Carroll Street/Graham Avenue neighborhood. Since this was the first step out of the Water Street/River Street neighborhood for Paterson's Jews, it was here that the future schoolteachers learned how to be Americans. Pictured here is a School No. 6 first-grade class from the 1930s.

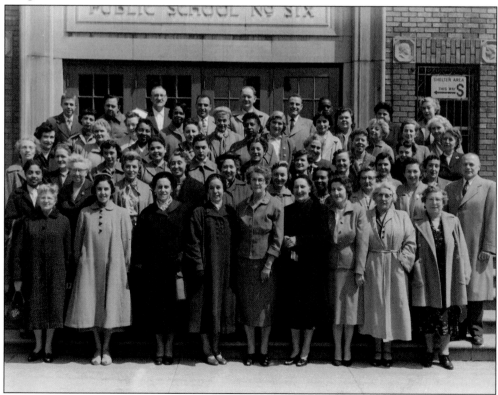

Many of the teachers at School No. 6 had attended the school as children. Pictured here in 1956 are the school's teachers and staff. Among the Jewish teachers shown here are Fannie Dormant, Sylvia Shapiro, Selma Rosenblatt, Jenny Joelson, Dorothy Simon, Adele Friedman, along with Jacob Stein, the janitor.

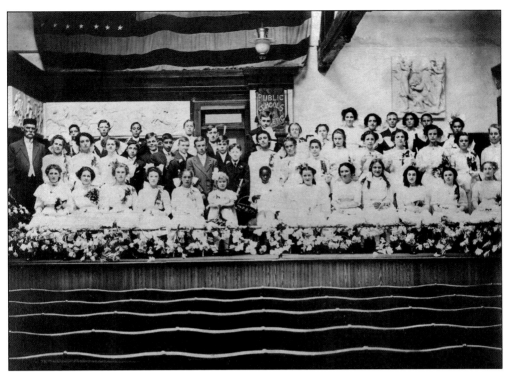

Bessie Weingartner Abrash, shown here in the center of the second row, attended School No. 10. The school was in the district adjacent to that of School No. 6, closer to the River Street neighborhood. School No. 10 had the distinction of being designed by Fred Wentworth, the architect of Temple Emanuel, Barnert Hospital, and Jacob Fabian's theaters.

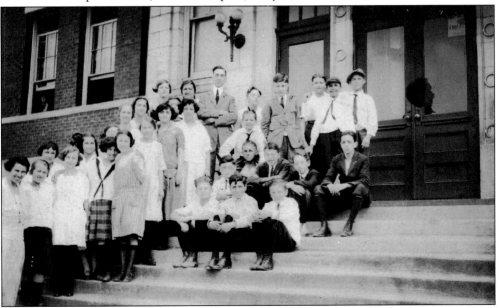

Lillian Roth attended School No. 12 in 1920. She is pictured with her graduating class in front of the school. Located on North Second Street, the school served the "over the river" neighborhood near Water Street.

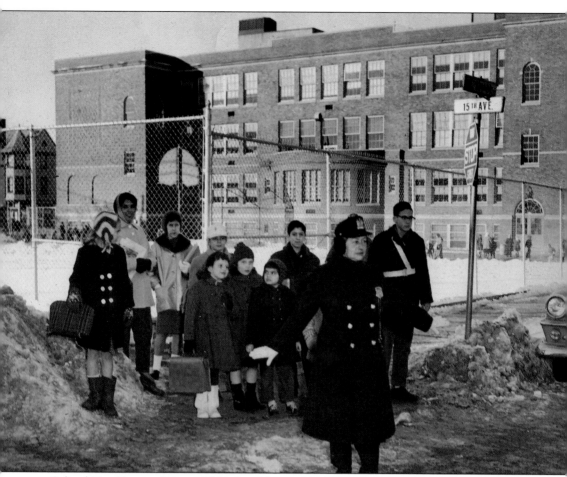

School No. 13 served the neighborhood located between Broadway and Park Avenue on the Eastside. Since the Paterson schools were neighborhood based, the students could walk to school. They did this twice a day—once in the morning and at lunchtime. The older children walked and supervised their younger brothers and sisters and the neighbors' kids. Since there were usually several major intersections on the routes to and from home, the schools hired crossing guards to ensure the children's safety. Ethel Reiner is seen here in the 1950s taking her job very seriously. As in the case of a teacher, all of the children knew her and respected her. Since she was the mother of School No. 13 students, she also knew the parents.

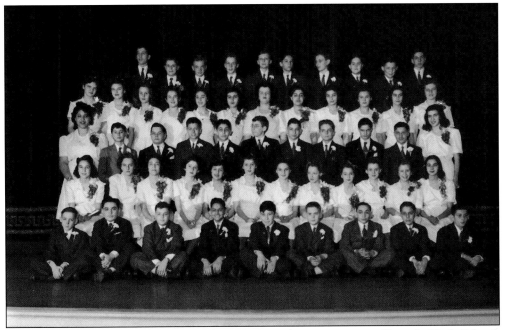

The School No. 13 graduating class of 1944 was ready to move on to Eastside High School. Among those shown in this photograph are Robert Levy; Ralph Rudnick, a future Eastside High teacher; Anita Waks; Leona Shulman; Iris Rudnick; Lila Zelinger; Lila Michaels; Lillian Boaz; Barbara Stern; Donald Weiner; Ellis Herman; Peter Rosenberg; Allan Cohn; Robert Schwarz; Arnold Stein; Marvin Cohen; and Philip Sachs.

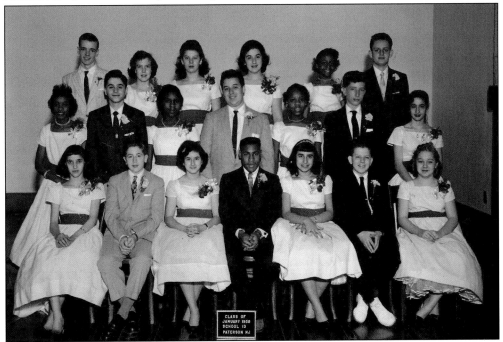

Among the 1958 graduating class of School No. 13 shown here are Norma Reiner Tempel and David Weinstock, both shown in second row on the right.

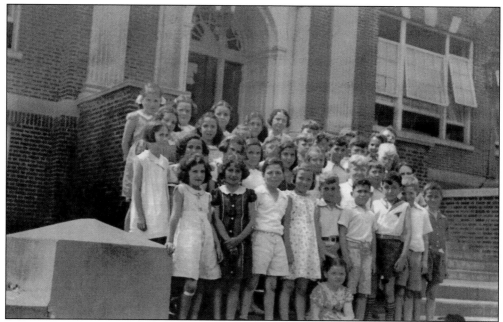

School No. 20 was located off of Vreeland Avenue on the Eastside. Included in this photograph of Miss Wood's class in 1937 are Sonia Segal (Goldberg), Richard Steinberg, Robert Jacobs, Cecile Sommers (Ulander), Joan Stern (Konner), Barbara Bloom, Marian Klein, Florence Goodman, Joe Behrens, Rita Kessler, and Marilyn Kanter, and Steven Coven.

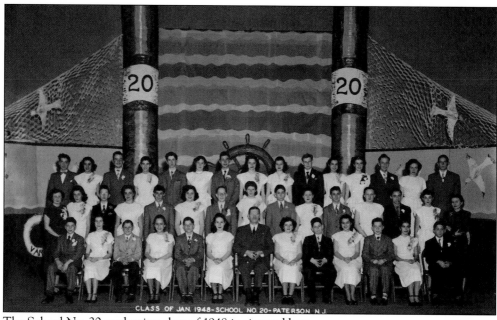

The School No. 20 graduating class of 1948 is pictured here.

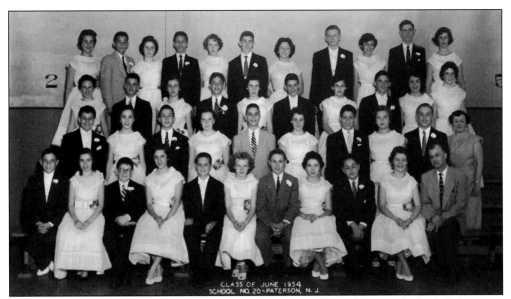

The School No. 20 graduating class of 1954 is shown in this photograph. Included among the students are Henry Ramer, Carolyn Flaxman, Robert Herz, Lois Hillman, Judy Feldman, Richard Altshul, Judy Hyman, Francine Sussman, Steven Gordon, Barbara Turndof, Henry Baum, Roseanne Gold, Fred Kaplan, Lloyd Singer, Linda Cohen, Marshall Goldberg, Judy Abramson, Paulette Bromberg, Michael Macowsky, Myra Zalon, David Waks, Joan Wexler, Walter Levine, Paul Markowitz, Barbara Opper, and principal Joseph Goldberg.

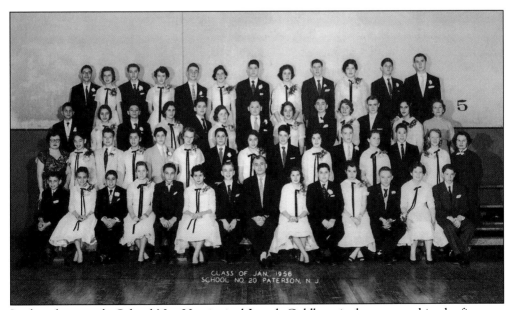

In this photograph, School No. 20 principal Joseph Goldberg is shown seated in the first row with the 1956 graduating class.

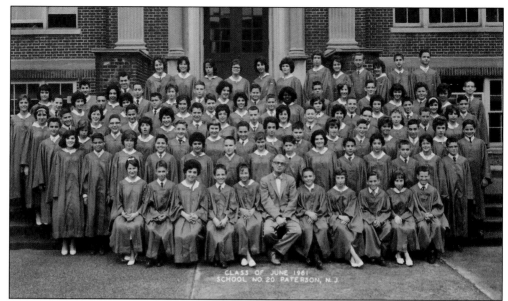

Michael Bornstein graduated from School No. 20 in 1961. Principal Joseph Goldberg is seated in the first row. Among those shown are Sima Gerber, Arnold Chesney, Robert Feldman, Beth Aronowitz, Bobby Sirota, Fred Feldman, David Schwartz, Aaron Jay, Ronald Levine, Steven Komar, Jay Mandelbaum, and Sandy Einstein.

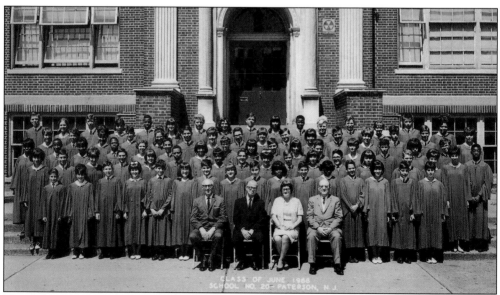

The School No. 20 graduating class of 1966, shown here, included Ronnie Nachimson, Lois Herman, Jay Merker, Arthur Poltan, Jane Zimel, and Bruce Neufeld.

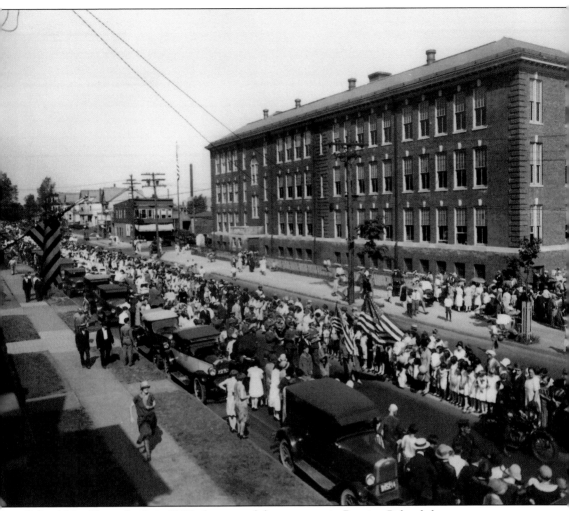

School No. 21 was built in 1905, the year of the pogroms in Russian Poland that sent so many Jews to Paterson. The school is pictured here in the 1920s during a parade celebration. A granite monument, seen to the left of the building, near the intersection of Tenth and Madison Avenues, included a plaque listing the School No. 21 graduates who had served in World War I. The school, located on Tenth Avenue, drew its students from the numbered streets between Seventh and Twelfth Avenues. In the 1950s, Herbert Lipsitz was the principal of School No. 21 until he left to become the assistant superintendent of the Paterson Public Schools. The school body was primarily comprised of Jews and Italians. Many of the teachers were the sons and daughters of the immigrants who came after 1905. They included Goldie Weiner, Rose Brown, Murray Greenbaum, Gloria Orleans, Gloria Segal, and Rae Biederman.

Shown here is Goldie Weiner's 1951 second-grade class at School No. 21. Among those shown, third from the left in the photograph are Roni Seibel and her younger sister Karen. At this time, the Paterson schools received an influx of new students, consisting of Jewish refugee children from Europe. Many only spoke Yiddish, so Goldie Weiner eased their transition by teaching them in English and speaking to them in Yiddish.

Rose Brown's 1953 second-grade class at School No. 21 is shown in this photograph. The occasion is Karen Seibel's birthday party; she is found in the second row, third from the left. Before she was married, Brown's last name was Barazowski. Since the children could not pronounce that, she changed her name to Barr. The author is in the first row, fourth from the left. (Courtesy of Roni Seibel Liebowitz.)

This photograph shows School No. 21's graduating class of 1947.

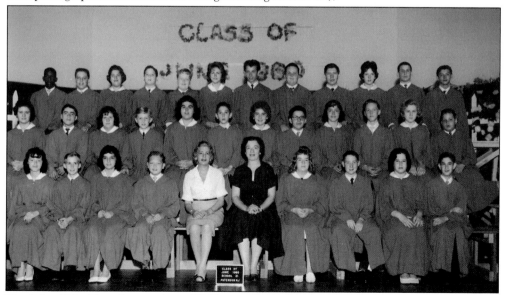

The School No. 21 graduating class of 1960 was so large that it occupied two full classrooms. Among those shown here with teacher Gloria Segal (first row, fifth from the left) are Roberta Goldring, Warren Sunshine, Eileen Landau, David Wilson, Debbie Blumen, Marsha Altshuler, Ira Friedman, Leonard Ginsberg, Kenny Brenner, Arlene Miller, David Hanowitz, and Philip Cantor.

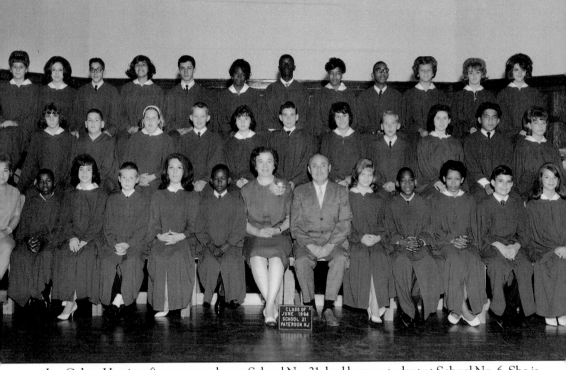

Ina Cohen Harris, a first-year teacher at School No. 21, had been a student at School No. 6. She is shown here at the far left in the first row, with the graduating class of 1964. Among the students shown are Reba Gutin, Pearl Lieberman, Mark Abo, and Jeanette Weiss. This was a baby-boom class that was so large it took up two full classrooms.

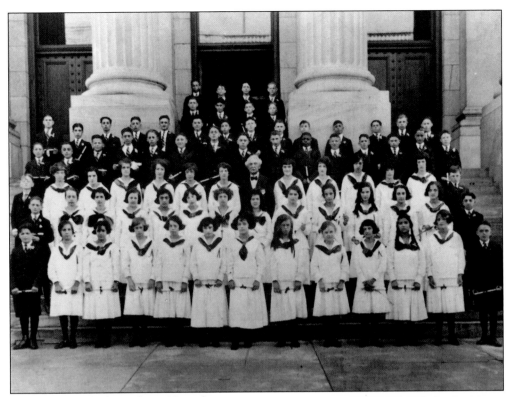

This photograph shows the 1923 graduating class of School No. 23. Mac DeLeon attended the school and graduated that year. He is seen in front of the left column in the fifth row, fifth from the left.

Barbara Farber Polaine (first row, far right) attended the Rose Batavia Children's School in 1929. Paterson had many nursery schools in the neighborhoods that catered to the children of working parents.

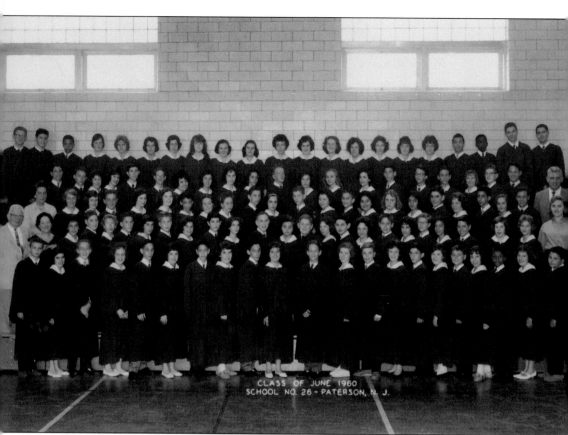

CLASS OF JUNE 1960
SCHOOL NO. 26 - PATERSON, N. J.

School No. 26 was a baby-boomer school built in the mid-1950s because of the increased student population born in the post–World War II period. Located near Eleventh Avenue and Thirty-second Street on Paterson's Eastside, the school drew students who had resided in the districts of Schools Nos. 13 and 21. Pictured here is the 1960 graduating class, which included Paul Wolfe, Mike Lubin, Flory Michaels, the Senack twins, Bev Grenker, Eric Uslaner, Art Davis, John Gruntfest, Ellen Kracower, Peter Dormont, Sharon Weiss, Diane Feitlowitz, Susan Pincus, Pat Collin, Arnold Lippa, Dennis Unger, Jill Michaels, Fern Beides, Toby Levy, Billy Gold, Rona Rosenberg, Sandy Alswang, Charlie Senak, Steve Liberman, Marcie Chrisman, David Croeland, and Lynn Maas.

Eight

YM-YWHA

As early as 1877, the Jews in Paterson wanted to build a social center that would provide its members with physical, social, educational, and cultural activities for all age groups. The Young Men's Hebrew Association (YMHA) incorporated in 1904, and the Young Women's Hebrew Association (YWHA) incorporated in 1906. Jews were barred from other clubs in the city, so in 1914, they opened their own social center and rented space at 97 Broadway. During World War I, the Y contributed to the war effort through a series of dances, concerts, and gift boxes for Jewish soldiers. Along with its other activities, the Y formed the Hebrew Literary and Debating Society. Later, the Y kept adding programs to meet community needs. After World War II, it helped the returning soldiers to reconnect. For refugees from European ghettos and concentration camps, it started the Americanization and integration process. In addition to all of the clubs and athletic programs, there were extensive arts programs. The Y had an orchestra, offered music lessons, and held performances by well-known musicians. The arts-and-crafts programs introduced all ages to creative expression and held art shows to display local artists.

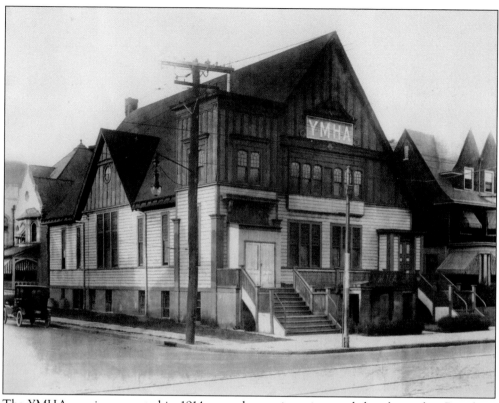

The YMHA was incorporated in 1914, moved to various sites, and then located to Broadway and Carroll Street. In 1919, the YMHA moved to Orpheus Hall (pictured here). With clubs and programs for all age groups, the Y met its members' needs at every stage in their lives. Paterson Jews' experiences here formed lasting bonds.

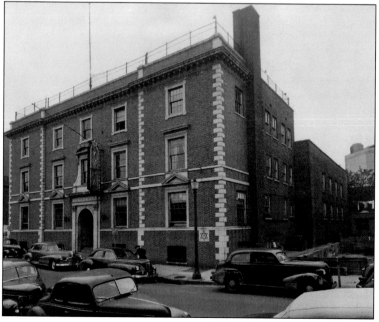

In 1925, the building on Van Houten Street was built. Finally, Jewish Paterson had a place to house athletics, clubs for all age groups, a summer camp, and music and art programs. With the population shift to the suburbs, the Y moved to Wayne in 1976. The building is currently used as the Norman Weir Public School.

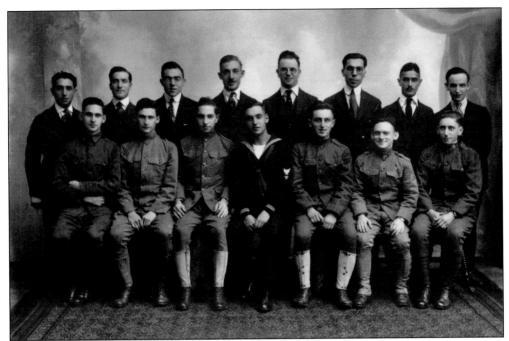

The Hebrew Boy's Association was an early Y athletic club. During World War I, many young Jews from Paterson enlisted in the army. In addition to sending soldiers, the YMHA and the YWHA supported the war effort by entertaining the troops and sending gift boxes. Former HBA members are pictured here at a reunion after World War I.

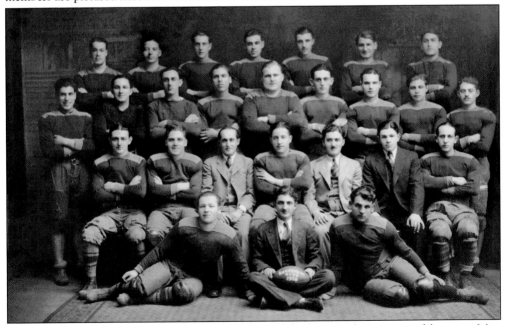

The Roosevelt Club was another early Y athletic club. Among those pictured here are Max Salzman, Henry Rosenberg, Henry Bressler, Jake Goldfarb, Dr. Al Widetsky, Bollie Morris, Sam Wiener, Lefty Berman, Solly Osur, Tiny Steiker, Sam Minsky, Aaron Slotkin, Ike Issacs, Ben Goldberg, Mac Dresner, Sam Chrisman, and Sid Libert.

The Golden Age Club was a social club for older adults. Activities were designed to stimulate their minds and their bodies through lectures, dinners, dances, trips, and athletics. Joseph Eisen (seated second on the left) is shown in this photograph and on this book's cover as a young man running a silk mill. On the cover, Joe is standing third on the left with his hand resting on the loom near his face

Golden Age Club dances were very popular weekly events, the big draw of which was to get out of the house and into a social situation. The real purpose of such a club was to allow people to schmooze or socialize. People played cards, read the Yiddish newspapers, and caught up on neighborhood gossip.

The Panther Club was a social club for adults that lasted for more than 30 years. The Panthers drew from newly married young adults and those with children who wanted to socialize. They performed skits and musicals and held dinners, dances, and picnics. As parents, they went through pregnancy together, raised their children together, and lived life and grew old together. Each year, they held a picnic that drew many families and couples. The Y community eagerly waited for the Panther Club musical and comedy events. Their most popular productions involved elaborate Broadway-type sets. Sometimes, the men would dress up as women and perform in drag to loud applause and catcalls.

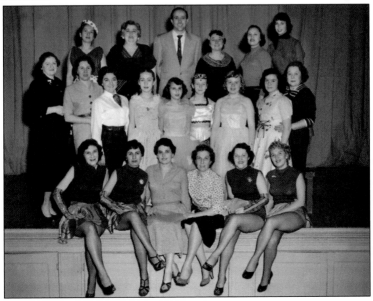

The Parents' Group started in 1926 to subsidize the Sunday school and to provide financial aid to needy students. It evolved to sponsoring Jewish holiday participation, supervising the Sunday school, and running the nursery school. The Model Family Seder during Passover was the annual highlight. In addition, the Parents' Group ran and maintained the Y's library and staffed the gift shop.

The Women's Group formed as a club for women to discuss books, current events, and cultural presentations. Shown here are, from left to right, the following: (first row) Rae Bromberg, Gloria Susser, Rose Tank, Helene Aronoff, Rae Gold, and Pauline Raskin; (second row) Ruth Bromberg, Lillian Izenberg, Ida Friedman, Elly Dall, Hilda Gelman, Ginnie Mann, Ruth Weiss, and Diane Agranoff.

The YMHA sponsored a strong scouting program early on. Volunteer troop leaders were recruited from among the parents, and some continued to participate well past the time their children were scouts. In this 1936 photograph, Troop No. 65 is posing in front of Temple Emanuel.

The Y Cub Scouts visited Washington, DC, in 1960 and posed with New Jersey senator Clifford Case. Among the scouts in the photograph are Leonard Zax, Steve Cutler, Norman Calka, Arthur Neufeld, Leon Kozak, Charlie Douma, Jack and Mark Abo, Meyer Rosen, and Michael Greene. Among the adults shown are Harry Zax, Alex Abo, Julian Douma, Bernie Neufeld, and Lou Gutin.

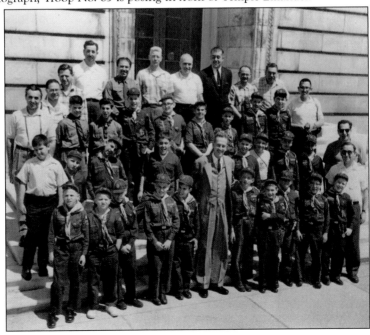

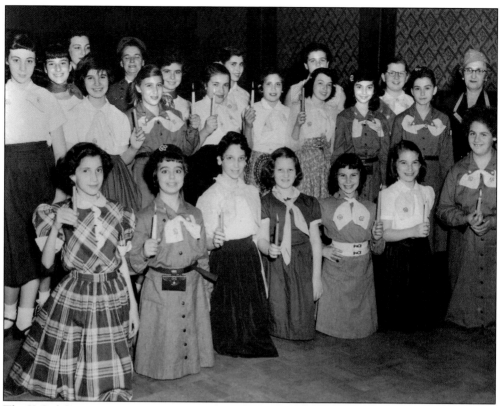

The Y Girl Scout program was as strong as the boys' program. Among the scouts shown in this mid-1950s photograph are Linda Belinfonte, Anne Fox, Liz Allison, Ruth Ann Kaufman, Rona DeLeon, Ronnie Smith, Deana Tosk, Gina Minsky, and Rachelle Miller.

The Brownies pose for a group portrait in 1956 during Halloween or Purim. This photograph contains just about all the Jewish girls in this age group in Paterson.

This Brownie troop is having a luncheon in 1960. Among those pictured are Lauren Solnik, Judith Diamond, Teri Smith, Susan Geneslaw, Jacqueline Terris, Marjorie Weiss, Jamie Greenwald, Cheryl Dorman, Judy Lee, Linda Walfish, Joan Berzin, Susan Dashow, Audrey Katz, Sylvia Solnik, Laurie Rosen, Laurie Krugman, Eva Weiss, and Bessie Berzin.

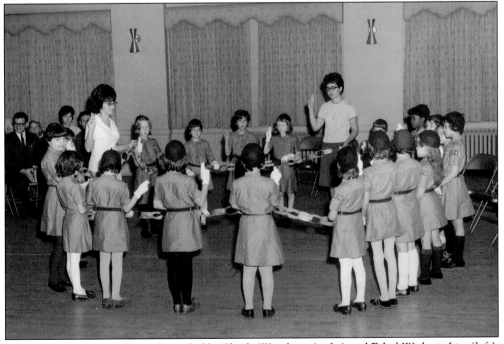

This Brownie troop is shown being led by Sheila Weinberg (right) and Ethel Wishnia Liss (left). Their husbands, Eastside High School teachers Irving Weinberg (far left) and Moe Liss (behind Ethel), are seated to the left.

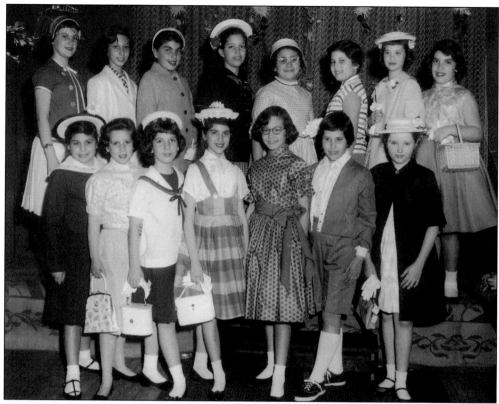

The Y sponsored the Paterson Jewish Youth Council for various age groups. Shown here in the 1950s is a group of preteen girls putting on one of many fashion shows. Among the girls posing together during this event are Carol Neufeld, Karel Ginsberg, Diane Feitlowitz, Sandy Rosen, Bev Grenker, Joan Schwartz, and twins Sandy and Rita Blumenthal.

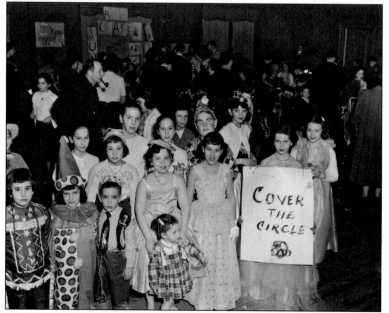

The YM-YWHA organized Purim carnivals for the children each year. The children dressed in costumes very much like those for Halloween. Among the children pictured here are Donna Roemer, the Mendelson twins, Betty Heller, and Arlene and Karen Elias. Purim carnivals were fun events that combined games, contests, and a holiday meal.

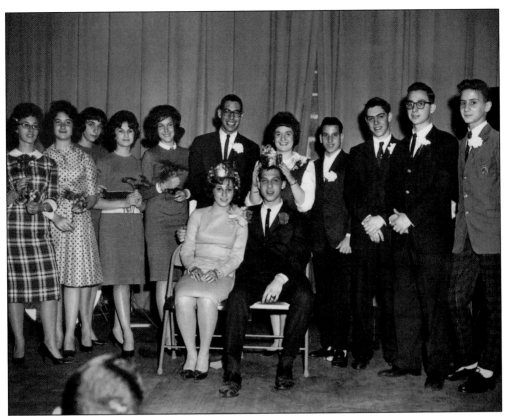

Along the lines of the children's program, the Y held Purim carnivals for the teenagers. Anna Jorkowitz and Stuart Liebowitz, crowned Queen Esther and Mordecai in 1961, pose for this photograph.

Ruth Berkowitz (second from right) and Mark Kahn (second from left) were crowned Queen Esther and Mordecai in 1962. Also present are Marsha Green and Jimmy Diamond (on either side of Ruth).

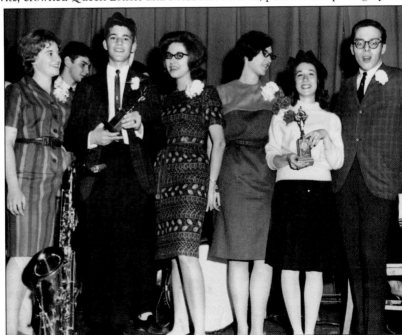

The athletic programs at the Y were central to its mission. Children came once a week for a general exercise and swimming program. They were taught the basics of individual sports and gymnastics. The girls' athletic program equaled the boys' in participation and commitment. The program was general and, aside from swimming, did not focus on any particular sport. After sampling all available athletics, individual children were assigned to one or more specific sports teams. These photographs capture the boys and girls in motion, playing basketball and doing gymnastics.

Basketball in the early part of the 20th century was known as "the Jewish game" because the best players were Jews and the most competition came from the Jewish clubs. Consider how African Americans dominate the game of basketball today to get a picture of American Jews' role in the sport in that earlier era. Meyer Music is holding the basketball in this photograph of the YMHA's 1916–1917 team.

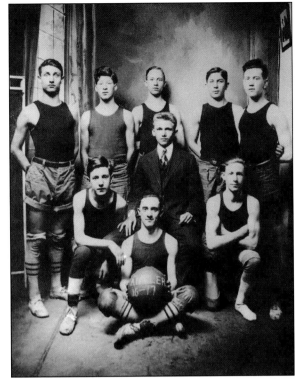

Among the 1926–1927 YMHA team members shown here are Meyer Music, Jake Moskow, Wink Taretsky, Mike Music, and David Shulman.

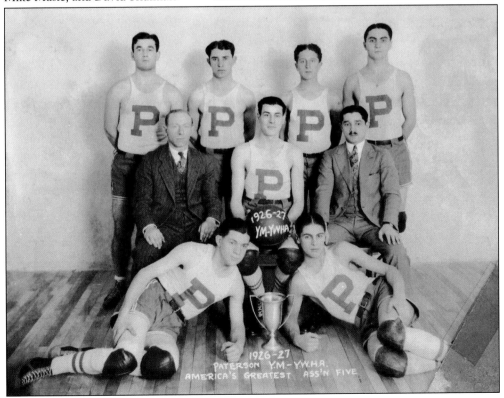

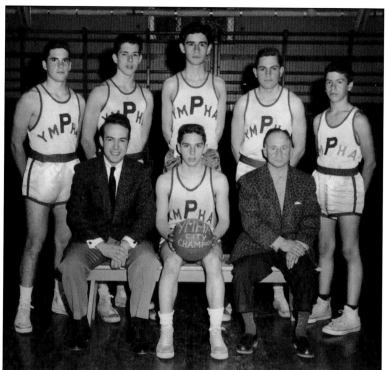

The youth basketball program in the late 1950s and the 1960s was run by coach Sol Levin, seated on the right, and assistant coach Hal Simon, seated on the left. Here, they are with the 1957 Y team, including Mel Druin, Richie Moskow, Edgar Weinstock, and Norman Greenberg.

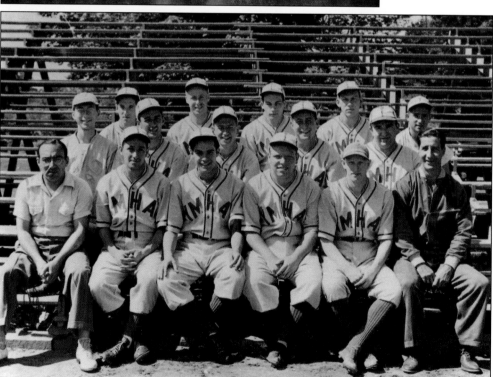

The Y also fielded baseball teams for all ages. This 1940 team included Moe Schepps, Whitey Berman, Mort Rittenberg, Sid Klein, Lou Sirota, Cookie Fisherman, and Sid Osur.

The Passaic County Biddy Basketball champions of 1957–1958 included Jack Zakim, Henry Chesin, Bruce Haft, Larry Grylock, Lewis Wishman, Donnie Grenker, and Robert Reines.

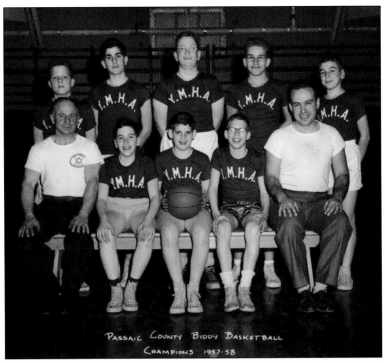

The 1964–1965 junior varsity basketball team included Gerry Rosen, Alan Zaks, Steven Gruntfest, Steven Kwiat, Nate Haft, Jim Farber, Eddie Smith, Sandy Einstein, Elliot Halpern, and Ira Rosen.

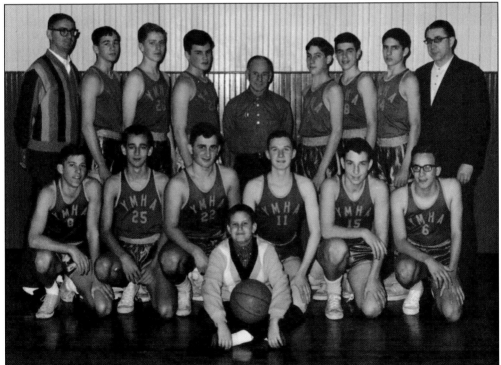

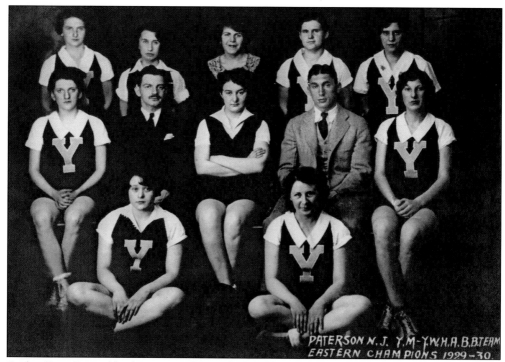

Sophie Davis Levin (third row, second from the left) played on the YWHA basketball team that was coached by Willie Singer (second row on the right). Daisy Cohen Resnick (second row on the far right) was also on the team. The 1929–1930 team, shown here, won the Eastern Championship Title.

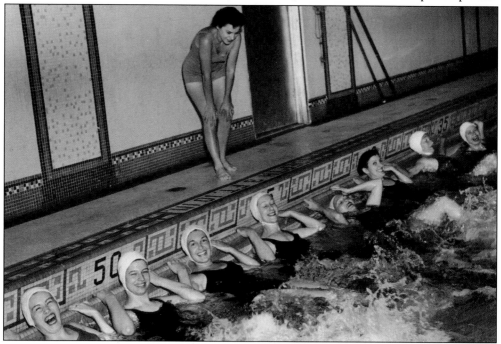

Swimming was an important part of the women's athletic program. In this photograph, the women are obviously enjoying themselves during an afternoon class.

Nine

SOCIAL WELFARE

In the early part of the 20th century, social services and welfare for Paterson's Jewish community fell into two categories. The first were the Barnerts and Jacob Fabian, who built institutions to serve the entire community. The second were mutual aid societies based on occupation or hometown in Russian Poland. They bought group life and health insurance policies for their members, bought group cemetery plots, and collected money for widows, orphans, and members who became disabled at work. Other programs were run by the synagogue congregations. Barnert Temple's Hebrew Ladies Benevolent Society collected and distributed food and clothing for the needy. A Mrs. Kravitz ran Hachnosas Orchim (Jewish Traveler's Aid) out of her home on Fair Street for transients seeking temporary lodging and food. Congregation B'ai Israel provided clothing to the poor through the Malbish Arumin Fund. The Hebrew Free Loan Association is still operating, providing small loans to people who cannot obtain loans elsewhere. And a provision in Nathan Barnert's will funded the Moas Chitim Fund, which distributed Passover matzos for the poor.

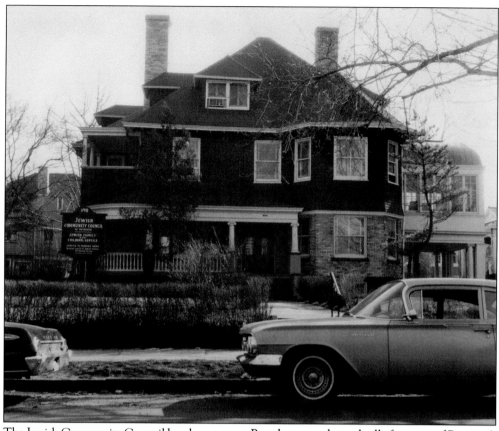

The Jewish Community Council headquarters on Broadway was the umbrella for many of Paterson's Jewish charities and social welfare programs. The community council evolved into the Jewish Federation of North Jersey, which funds Jewish Family Service. After World War II, it helped settle Jewish refugees from Europe.

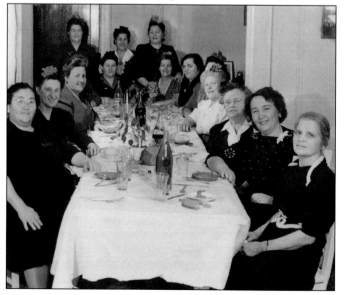

The Hebrew Immigrant Aid Society (HIAS) assisted immigrants through the entire process. Its work began with the early waves of immigration, from the beginning of the process in the old country, arranging for transportation to and from ports, to providing dormitories for people waiting for ships and for those who arrived in America, to job referrals and family reunification. This HIAS committee, photographed in 1940, did all of that for Paterson.

The Independent United Jersey Verein was formed in 1914 to provide financial assistance to sick and disabled members of the community. It also provided scholarships for students, donated wheelchairs to hospitals, and bought group life and health insurance policies for its members. There were many mutual aid societies like this in Paterson.

The Jacob Dineson Lodge was named for a famous Yiddish writer. The Paterson branch formed in 1919 to promote Yiddish cultural programs by providing Yiddish language books and newspapers for its members, arranging lectures and the opportunity to meet writers, and holding political debates. Later, the lodge raised money for Jewish charities.

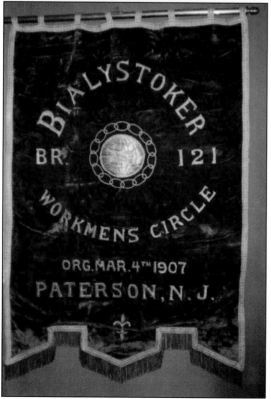

The Independent Lodzer Young Men Landsmanschaft was a group formed to assist immigrant members from the city of Lodz who became sick or disabled. These Landsmanschaften proliferated in the immigrant communities. In a time when individual insurance was either too expensive or unavailable, they purchased group cemetery plots and later contributed to national Jewish charities.

Bialystocker Landsmanschaft was a group formed to assist members from the city of Bialystock. It, too, functioned by providing group disability and health insurance for its members. It also was a social club that held dinners, dances, and picnics. The other landsmanschaften in Paterson were the Ozerkover Society and the Pabianitzer Society.

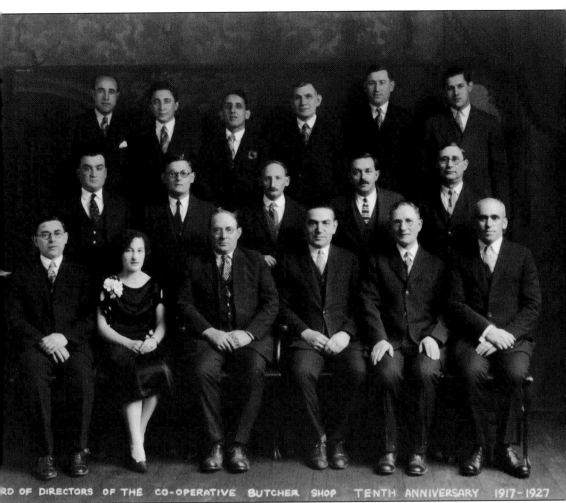

RD OF DIRECTORS OF THE CO-OPERATIVE BUTCHER SHOP TENTH ANNIVERSARY 1917-1927

The Purity Butcher's Cooperative was established after the silk strike of 1913 and was connected to the bakery cooperative. Its purpose was to provide uniform standards for kosher meat sold in Paterson and to insure food for the needy. It functioned as a trade association that had a religious and social mission. The commercial streets in the Jewish neighborhoods of Paterson were lined with kosher butcher shops. Tenth, Park, and Graham Avenues and Washington and River Streets often had two or three such shops to a block. A distinctive sight was the weekly visit of the *shochet*, or ritual slaughterer, who walked up and down these streets carrying his special tools in a leather bag. He visited all of the butcher shops to kill the week's supply of chickens.

117

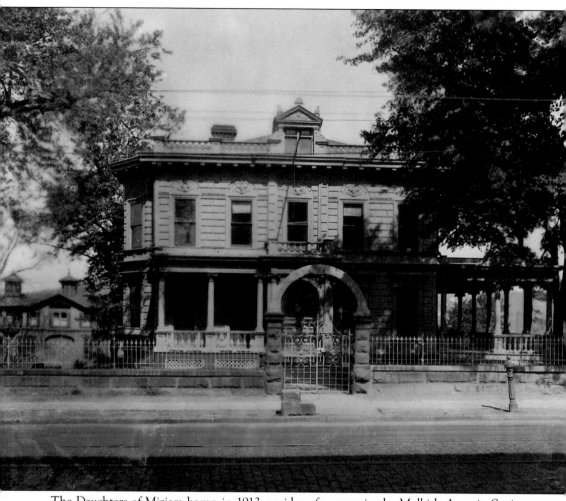

The Daughters of Miriam began in 1913, an idea of women in the Malbish Arumin Society as a shelter for both orphans and the elderly. In 1916, Nathan Barnert purchased the Bailey Estate at 469 River Street as a memorial to his wife, Miriam. In 1926, Barnert led the development of an elaborate campus that housed the programs on a site of farmland neighboring Clifton, New Jersey. In 1950, the Daughters of Miriam phased out the orphans program and transferred it to the Jewish Social Services Bureau (now known as Jewish Family Service of North Jersey). The children were placed in foster homes or given up for adoption. The program became dedicated to serving the elderly as a nursing home. In 1957, it merged with the B'nai Israel Home for the Aged in Passaic, New Jersey. Today, it is a skilled nursing and a certified extended care facility with a national reputation. The pioneering concept was to create a continuous care program on the 18-acre campus providing congregate dinning, independent living, assisted living, and nursing care.

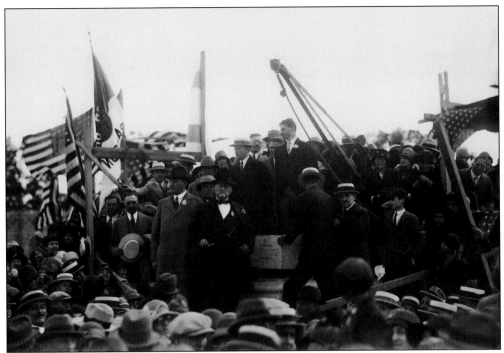

Nathan Barnert was central to establishing another Jewish communal institution. He is shown here speaking at the ground breaking ceremony in 1926 for the new Daughters of Miriam building.

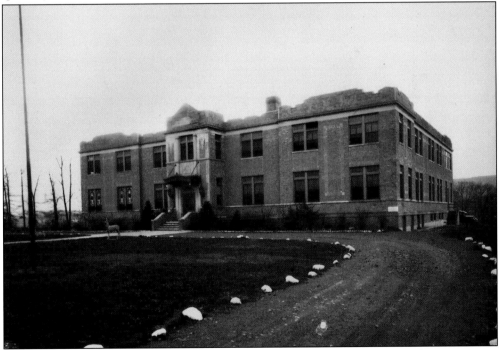

The new building was constructed on the former Ezorsky-Mendenkowski farm in Clifton, New Jersey. It included dormitories, a gym, classrooms, and a dining room. By the 1950s, the orphans program was transferred to Jewish Family Services and the facility served the elderly exclusively.

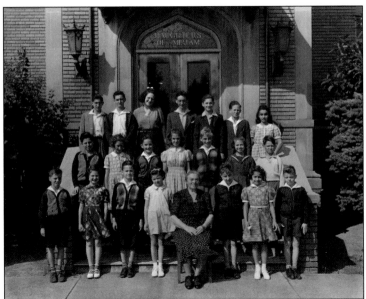

Mrs. Siegel was the housemother for the Daughters of Miriam's orphan program. The children lived and ate here but attended public schools and visited Jewish families in Paterson. This photograph, taken in 1936, includes Jerry and Stanley Bender and Gloria and Marty Gold.

The program for the elderly was highlighted in a *Wall Street Journal* profile, which described the unique character of the institution. No amount of planning could create the very high level of communication between management and the residents at the nursing home. Because most of the residents and their adult children knew each other from living together in Paterson, instead of fielding individual complaints, the residents talked to their children, who then discussed the problems collectively. The management was then able to respond quickly and effectively. Over time, the level of trust increased into making this a high-level problem-solving mechanism.

Ten

FAMOUS PEOPLE

.

Paterson has been the home of several notable people. Albert Sabin and Irving Selicoff were internationally known doctors and medical researchers who contributed enormous medical breakthroughs to the world. Morris Joelson had more of a local reputation but was a hero doctor, and everyone considered to be an example of a decent man. Charles Joelson and Frank Lautenberg served in the US Congress. They made sure that not only was Paterson's interests attended to from the federal government but that Jewish interests were represented, as well. Sol Stetin was a nationally known labor leader who had worked in the silk mills early in the 20th century. He used that experience to organize a textile workers' union and later to provide leadership for several university programs. Allen Ginsberg was a well-known poet who was the most recognizable face of the Beat Generation. He never forgot Paterson and often mentioned it in his poems, especially in *Howl* and *Kaddish*. And he was a good son. He visited his father often and regularly. Bette Midler, the singer, while not born in Paterson, had her family roots there. Bruce Villanch, the comic writer, found a way to parlay his routines at Eastside High School into Hollywood productions.

Albert Sabin was born in Bialystok, in Russian Poland, in 1906 and came to Paterson with his family when he was 15 years old. His father worked in the silk mills as a weaver. Sabin learned English and graduated from high school in 1923. He attended New York University, received his medical degree in 1931, and began research on the virus that causes polio. This became his life's work. During World War II, Sabin interrupted his polio research and served in the US Army as a medical researcher concentrating on developing treatments and cures for infectious diseases that affected the troops. By 1954, Sabin had developed a vaccine that gave protection against polio. The Sabin vaccine used a live virus rather than the dead virus used by Dr. Jonas Salk for his vaccine. Both have proven effective treatment for polio. In his later years, Albert Sabin researched the possible connection between viruses and human cancer.

Charles Joelson was Dr. Morris Joelson's nephew. He attended school in Paterson and eventually became a lawyer. He practiced law in Paterson, served in the military, and, after his discharge, served as city attorney and as a state and county prosecutor. He served in Congress from 1961 to 1969 and was then appointed a judge in the Superior Court of New Jersey.

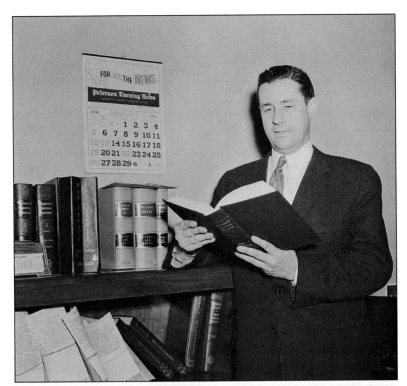

Frank Lautenberg (second from the right) was born and raised in Paterson. His father, Sam, worked in the mills as a warper, but his uncertain fortunes meant that the family was very poor and moved often. Nevertheless, Frank became a business success. After military service in World War II, he founded ADP Corporation. He was first elected in 1982 and is currently the US senator from New Jersey.

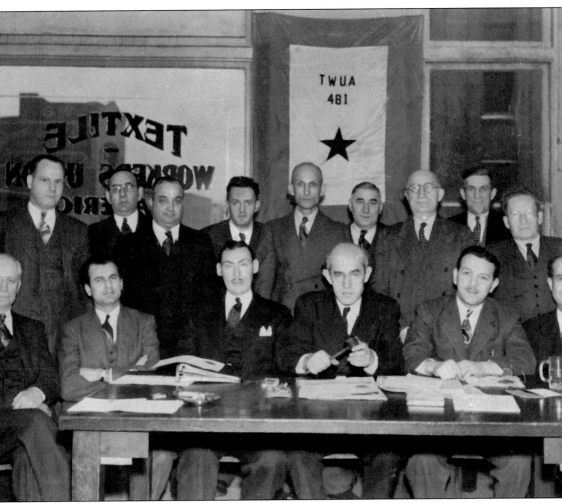

Sol Stetin (seated second from the right) was born in Poland and came to Paterson as a young child. He worked in the silk mills and became disgusted with the unsafe working conditions, low pay, and the system of fines and penalties. He therefore started organizing his fellow workers into a union. He founded the Amalgamated Clothing and Textile Workers Union, serving as president of the union. He was a member of the National AFL-CIO Executive Council. He also served as a trustee for William Paterson University and helped organize the Institute of Management and Labor Relations at Rutgers University. Stetin also was one of the founders of the American Labor Museum, where he served as president from 1980 to 1992. In the Academy Award–winning film *Norma Rae*, directed by Martin Ritt, one of the characters is based on Sol Stetin.

Allen Ginsberg lived on Hamilton Avenue and went to School No. 6 in Paterson. His father, Louis, was a published lyric poet and a teacher at Central High School. Ginsberg's mother, Naomi, was a communist, committed to politics and social justice. She suffered from mental illness and was repeatedly hospitalized when Allen was a child. Ginsberg attended Columbia University with a scholarship from the YMHA. He was influenced by William Carlos Williams, a poet and a doctor who practiced in Paterson. His two poems with the most direct Jewish content are *Kaddish* and "To Aunt Rose." Ginsberg is seen above with his father, Louis, giving a joint poetry reading at the Ninety-second Street YMHA in New York City. Allen, on the left, is seen below at his New York apartment with father and brother Eugene.

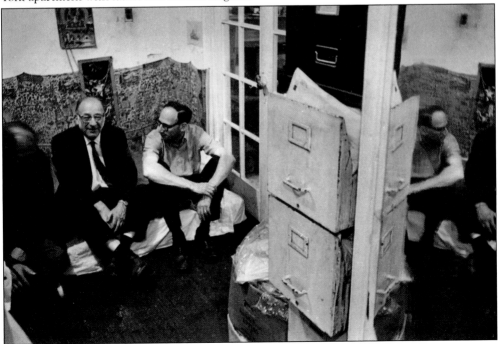

Allen Ginsberg returned frequently to Paterson to visit his father, Louis. Louis was a well-known figure in Paterson, being an English teacher and Allen's father. Louis liked to hang out at the Paramount soda fountain on Vreeland Avenue and hold court. He was famous for cracking jokes and making up puns. In the mid-1960s, Allen and Louis gave a series of joint poetry readings at the YMHA in Paterson. Allen, the world-famous poet, shared the stage with his father, also a poet, to the audience's delight. After the reading, Louis, clearly embarrassed, went to all of his friends and said, "I told him not to use bad words. But do you think he listens?"

ABOUT THE
ORGANIZATION

The Jewish Historical Society of North Jersey (JHSNJ) is located in the old Barnert Hospital in Paterson, New Jersey. The society houses historic records, photographs, and memorabilia from the Jewish communities of Passaic, Bergen, and North Hudson Counties. The society collects local Jewish records and artifacts—written and printed records from organizations and congregations, biographies, photographs, and books.

In addition, there are recorded oral interviews. The JHSNJ is a nonprofit 501 (c) 3 corporation that accepts tax-deductible donations. JHSNJ, 680 Broadway, Suite 2, Paterson, NJ 07514. The society also has a Facebook page.

DISCOVER THOUSANDS OF LOCAL HISTORY BOOKS
FEATURING MILLIONS OF VINTAGE IMAGES

Arcadia Publishing, the leading local history publisher in the United States, is committed to making history accessible and meaningful through publishing books that celebrate and preserve the heritage of America's people and places.

Find more books like this at
www.arcadiapublishing.com

Search for your hometown history, your old stomping grounds, and even your favorite sports team.